IMAGES
of America

JACKSONVILLE AND CAMP LEJEUNE

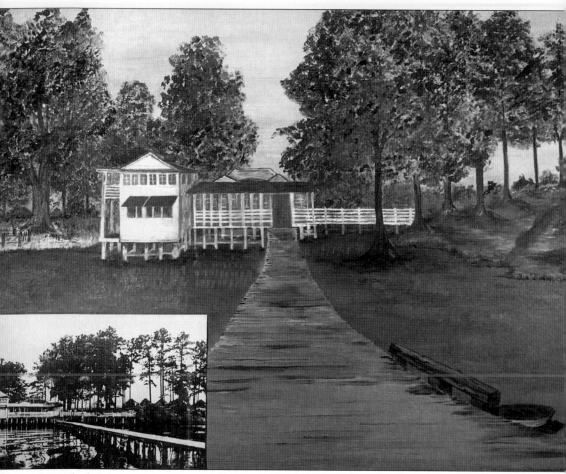

Montford Point was a recreational area on the banks of New River in the 1920s and 1930s. Owned and operated by Z.E. Murrell and his wife, Louise, it was a place where church picnics, holiday celebrations, and birthday parties were held, as well as a great place for swimming, boating, and relaxing. The painting above shows Montford Point prior to the establishment of Camp Lejeune, and the inset image shows the area after Camp Lejeune's establishment. The social structure and the entire way of life in Onslow County changed during World War II. The rural way of life and the lazy days were gone. (Painting by Billie Jean Murrell; collage by Dr. Stratton C. Murrell.)

IMAGES
of America

JACKSONVILLE AND CAMP LEJEUNE

Stratton C. and Billie Jean Murrell

ARCADIA

Published by Arcadia Publishing,
an imprint of Tempus Publishing, Inc.
2 Cumberland Street
Charleston, SC 29401

Printed in Great Britain.

Library of Congress Catalog Card Number: 2001089051

For all general information contact Arcadia Publishing at:
Telephone 843-853-2070
Fax 843-853-0044
E-Mail sales@arcadiapublishing.com

For customer service and orders:
Toll-Free 1-888-313-2665

Visit us on the internet at http://www.arcadiapublishing.com

*This book is dedicated to the people of Onslow County—
past, present, and future.*

CONTENTS

INTRODUCTION

Modern European contact with what is now Onslow County may have come about in 1524—perhaps near Bogue of the New River Inlet area—during an exploratory voyage of Giovanni da Verrazzano, sailing on behalf of France. Verrazzano was greatly impressed with what is now the Carolina coast, but France failed to follow up on this discovery and the coast was open to other settlement efforts, mainly by England's Sir Walter Raleigh in the 1580s. Raleigh's North Carolina coastal settlement efforts failed, and England's first permanent colony was established in Virginia in 1607. Settlement of the coastal lands south of Virginia was very gradual, reaching the Pamlico area by the end of the 1600s and into the Neuse-Trent area by the first decade of the 18th century.

After the defeat of the local Native Americans in the Tuscarora War (1711–1714), the expansion of North Carolina's southern coastal area progressed. The settlers migrated from the Bath Precinct (1696), which was subdivided to the Archdale Precinct and this was later renamed the Craven Precinct. The Carteret Precinct was created in 1722, the New Hanover Precinct in 1729. The coastal wilderness between Morehead City and Wilmington made it difficult for the people living on the banks of New River to transact legal affairs in either of these places. For this reason, Onslow Precinct was carved out of New Hanover and Carteret Counties in 1731. Land grants were issued in 1713–1714 and again in 1730, but history notes that as many as half of the land grants in the Onslow area were issued to non-residents.

The people who lived here needed a courthouse so that they could transact legal business. Onslow was elevated to county status in 1739. Joseph Howard was a county magistrate and presided over the first court session, which was held at his plantation on Blue Creek at Olde Town Point. Various sites for a courthouse existed, but fire or storms destroyed the early courthouses, and the county commissioners decided to move upriver for safety, building a courthouse on New River at Wantland's Ferry. A settlement grew up around this area, providing for business transactions, trading, lodging, and social gatherings. In 1819 it was named Onslow Courthouse, and in 1842 the name was changed to Jacksonville in honor of President Andrew Jackson, who was born in North Carolina. With the replacement of Wantland's Ferry with a bridge across New River and with the coming of the railroad from Wilmington to Jacksonville and New Bern, the town's population, which numbered 309 in 1900, grew to 873 by 1930. The year 2000 would record a population of 70,365. This pictorial history represents these people—the people of Jacksonville and Camp Lejeune—who have taken the area from a primitive beginning to a rural metropolis.

The intent of our book is to be as accurate as possible, but there may be questions regarding the dates of some of the events pictured. We have consulted numerous sources and find that in many instances there are conflicts in the information. Despite these discrepancies, our basic concern is to trace the development of Jacksonville, which grew from a small coastal village into a city and annexed Camp Lejeune in 1990, thus becoming a unique metropolis of importance to international security.

ACKNOWLEDGMENTS

Many friends and acquaintances of Jacksonville and Camp Lejeune gave liberal encouragement for our gathering of pictures and information. Many individuals and organizations contributed to this project making it possible to appreciate what was, what is, and what may be for the city of Jacksonville, the home of Camp Lejeune.

We would like to thank the following organizations and individuals that made this volume possible.

The *Daily News* started it all by making us aware that Arcadia Publishing of Charleston, South Carolina, was interested in finding someone to do a pictorial history of Jacksonville/Camp Lejeune, North Carolina. Additional thanks go to the editor and staff of the *Daily News* for encouragement and cooperation as this project began and progressed. The Onslow County Public Library provided space for a "picture gathering reception" for those interested in the project. Our sincere appreciation goes to the staff, especially Joan B. Dillemuth and Estelle Carter, for their patience and persistence; Anna Hamilton and Katherine Pace for so graciously receiving those who came to bring pictures of the very early scenes of Jacksonville and Camp Lejeune; Mrs. Thelma B. Langley and Mrs. Marie Koonce Moore for sharing pictures, scrapbooks, and historical information; and Rex Avery, Donald Tallman, Joe Bynum, and L.J. "Kim" Kimball for historical information as well as vintage pictures.

Our sincere appreciation is also extended to Patsy Cape, Jean Schall, Cris Koonce, Steve Sayko, Jack Bright, Gerald Hurst, Pat Blankenship, Jack Howard, Tom Mattison, Vicki Allen, Olese Walton, Eloise Walton, Billy and Sylvia Fountain, Jim Hamilton, John Drew Warlick, Bob and Carole Lock, Carlyle and Sylvia Sanders, Estel Silance, Carol Taylor, JoAnn Becker, Steve and Alma Hemby, Billy Morris, Barbara Daughtery, Marjory Berry, Judge Harvey Boney, Jerald "Scotty" Humphrey, Audry Bridges, Mark Petteway, Hedrick Aman, Grady Gillenwater, Mildred Twyman, Geneva Chadwick, Dick Tallman, George Rhodes, Linwood "Sparky" Peed, Clark Ruse, Wayne Morris, Matt Hardiman, Paul Siverson, Hettie Lucinda Ward, Marilyn Nita Margolis, Naomi Cardwell, Juanita Brown, Everitte Barbee, Ed Cole, Mildred Thomas, Nelson Calhoun, Phyllis Calhoun, and Lindsay Russell for their generous donation of pictures and historical data. John Rhodes, Sarah and Ray Humphries, Henry Humphrey, and Benjamin Wilson supplied additional historical data.

We are grateful to Mary T. Parker for making available to us additional stories and pictures of her grandfather, William T. Harding, who was the chief engineer for the construction of the first steam plant at Camp Lejeune. Thanks also to the Onslow County Museum, director Al Potts, and the museum staff, especially Lisa Whitman-Grice and Patricia Hughey.

Additional thanks to the many people in Jacksonville and throughout the county and state for telephone calls to share memories and historical information regarding Jacksonville's early "boom days." To all those who offered their goodwill and encouragement we are very grateful.

Thanks to Tom Mattison for his enthusiasm and for informing the public about our book on his radio program at WSTK. Appreciation is extended to Lane Cox for his expertise in

photography and for helping us in our time of need, and to Carmen Miracle, city clerk, for supplying much last-minute information.

The major historical sources for our book include, but are not limited to, the following:

The notes of Tucker Littleton on file at the Division of Archives and History, Raleigh;
Various research papers and lectures by L.J. "Kim" Kimball;
The Commonwealth of Onslow: A History, by J. Parsons Brown;
Onslow County: A Brief History, by Alan Watson;
Architectural History of Onslow County, by J. Daniel Pezzoni;
The Heritage of Onslow County, published by the Onslow County Historical Society in cooperation with Hunter Publishing Company of Winston-Salem;
Old Onslow Times, historical information compiled by John Rhodes;
Personal notes and information in the author's historical data collection, Coastal Carolina Connections;
Steve Massengill, North Carolina Department of Cultural Resources, Division of Archives and History, Raleigh;
Keith Longiotti, Wilson Library, University of North Carolina at Chapel Hill;
J. Renee Hawthorne, deputy assistant chief of staff for Training and Operations Department, Marine Corps Base, Camp Lejeune; and
Marine Corps Base Graphics Department, Camp Lejeune.

One
THE TOWN AROUND
THE COURTHOUSE

Jacksonville/Camp Lejeune is located in Onslow County, North Carolina, and the town's history relating to its becoming the county seat and the site of the county courthouse is quite interesting.

The Native Americans on the east coast of what is now North Carolina began to see a different kind of person arriving on these shores in the early 1700s. Even though they were ill-prepared to live on this land, the newcomers proved themselves to be of fairly hardy stock, and they began small settlements. The land, rivers, and streams became their means of livelihood.

Many who came to the area, later known as Onslow County, were from the more eastern sections of the Carolina Colony or the shores of Virginia. Travel was difficult and the population was scattered. So problematic was it for people to get from the area now called Onslow to Wilmington in New Hanover County or Beaufort in Carteret County to take care of their legal affairs that in 1734 Onslow County was formed from parts of those counties. A small courthouse was built on the New River and, later, another at Johnston. The first was destroyed by fire and the one at Johnston was destroyed by the great hurricane of 1752. Another courthouse was built at Wantland's Ferry landing and the spring.

The Wantland site was renamed Onslow Courthouse in 1819 and, in 1842,renamed Jacksonville. The community became the county seat and grew as a result of the establishment of the courthouse. History would see this area grow from wilderness to a bustling town. It would also witness the community being dragged "kicking and screaming" into World War II, a result of the establishment of Camp Lejeune, a huge military base.

Turpentine Orchards was the work of Samuel Chadwick, a whaler from Falmouth, Massachusetts, who came to the coast of North Carolina in the early 1700s and settled in what is now Carteret County. He became a sheriff and developed Turpentine Orchards into what is now Onslow County. Turpentine was a critical naval store, which literally kept the British Navy afloat. (Artwork by Billie Jean Murrell.)

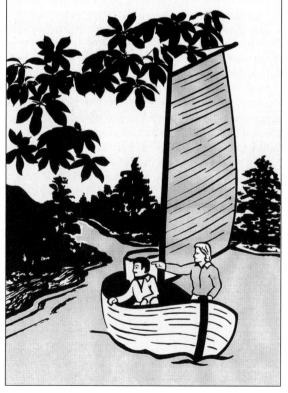

The Dexter brothers, whalers from Falmouth, Massachusetts, were the first permanent settlers of Onslow County in 1714. They were probably part of Samuel Chadwick's crew. Hope Dexter had a large land grant of 640 acres in Onslow County and was the founder of Johnston, established in 1741. Swansboro was founded by Theophilus Weeks, also of Falmouth. (Courtesy of Rose Avery in honor of her father, Rex Avery.)

The marshlands and pine thickets of North Carolina's coast made travel difficult except by water. As late as 1741 the residents of the New River area were forced to transact their legal affairs at Beaufort or Wilmington. (Courtesy of Tom Mattison, River Keeper.)

There were a few large plantations and some cleared farmland in this area, but most of the land was covered by thick vegetation, making travel difficult. A new precinct was needed as a political entity for the New River area in order for the people to more conveniently transact legal affairs. Onslow Precinct was carved out of parts of Carteret and New Hanover Counties. (Photo by Dr. Stratton C. Murrell.)

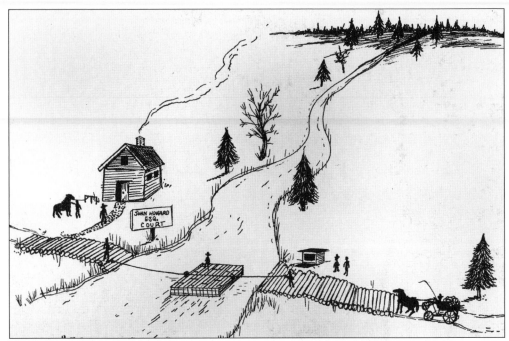

This sketch depicts Joseph Howard's Plantation, an early site of court proceedings in the community. John Williams reneged on his contract to build a courthouse in Onslow Precinct, so Joseph Howard, a magistrate at the time, decided to hold court at his plantation on Old Town Point in 1735. (Sketch by E.J. Ham; courtesy of Jack Howard.)

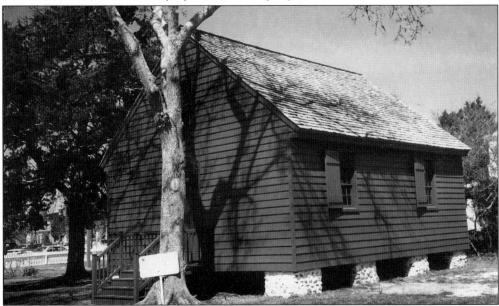

Joseph Howard and his son built a courthouse at Paradise Point in 1737; it was destroyed by fire in 1744. Johnston was incorporated in 1741 and a courthouse built at this site, but this courthouse, all public records, and the entire town was destroyed by a great hurricane in 1752. This is a picture of a similar courthouse constructed in Beaufort, North Carolina, in 1796. (Photo by Dr. Stratton C. Murrell.)

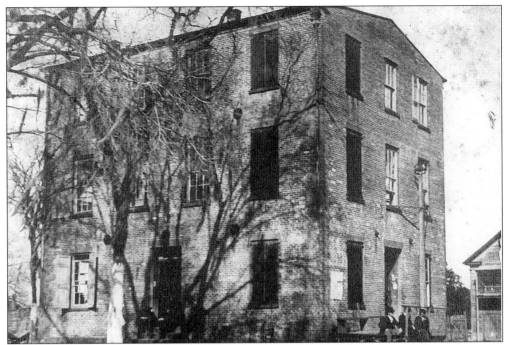

The legislature decided to build a courthouse upriver in a more protected area at Wantland's Ferry. A town grew up around it, and it was incorporated as Onslow Courthouse in 1785. In 1842, the name was changed to Jacksonville. Another courthouse was built in 1884 and served the people until 1904, when it was torn down because of its poor condition. A third courthouse was built on the same spot by B.F. Smith Fireproof Construction Company. (Courtesy of the Department of Archives and History, Raleigh.)

One of the first courthouses in Jacksonville in the 20th century stood at the same site as the first one built at Wantland's Spring. This is the courthouse built by B.F. Smith Fireproof Construction Company in 1904. The spring still exists and may be found on the present Pelletier House property on Old Bridge Street. (Courtesy of Olese and Eloise Walton.)

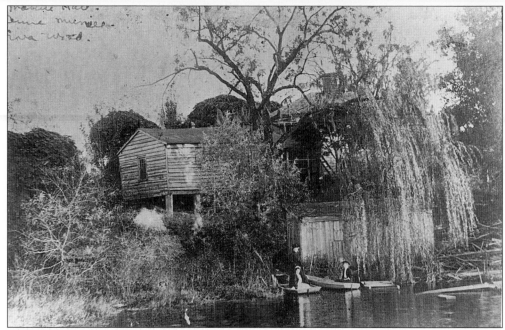

James Wantland gave one acre of land to the county for the construction of a courthouse, which was built convenient to Wantland's Ferry and Spring. This picture of the Pelletier House is the earliest extant picture of a private dwelling at Wantland's Ferry. From left to right are Mamie Hall, Anne Murrill, and Eva Ward in 1910. (Courtesy of Olese and Eloise Walton.)

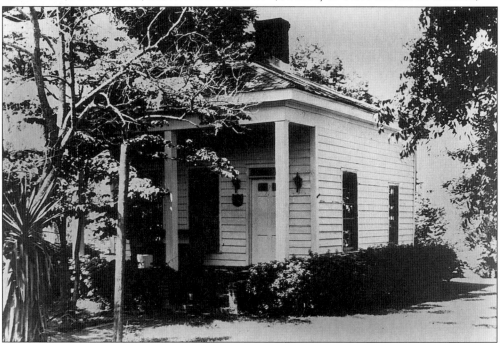

Pelletier House at Wantland Spring, the oldest standing structure in Jacksonville, was built in the 1850s by Rufus Pelletier. It is pictured here on Old Bridge Street. (Courtesy of the Department of Archives and History, Raleigh.)

John W. Burton was Jacksonville's first mayor of the 20th century. He was also the president and principle owner of the Bank of Onslow, the first bank established in Onslow County in the 1890s. The bank was first located in the courthouse, as were the offices of many town and county agencies. (Courtesy of Lee Burton Caliguiri.)

The Bank of Onslow moved across from the courthouse into another building on Old Bridge Street. It merged with First Citizens Bank and Trust Company in the 1930s, and John W. Burton retained his position as president. This was one of the first indications that there were plans for the economic expansion of Jacksonville and Onslow County. (Courtesy of the Department of Archives and History, Raleigh.)

15

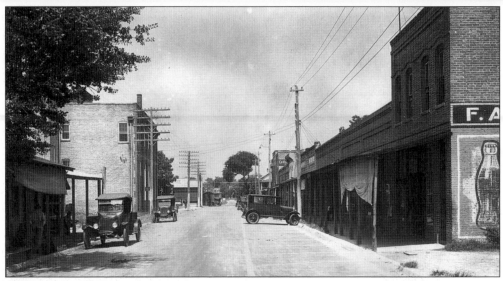

Court Street is depicted here in the early 1900s. While cars and buggies navigated the street, Henry Jarman drove cattle down the street and across the bridge in the morning so that they could graze and drove them back to his barn at the end of the day. Max Margolis raised cattle on the outskirts of Jacksonville and sold milk to town residents. (Courtesy of Billy Morris.)

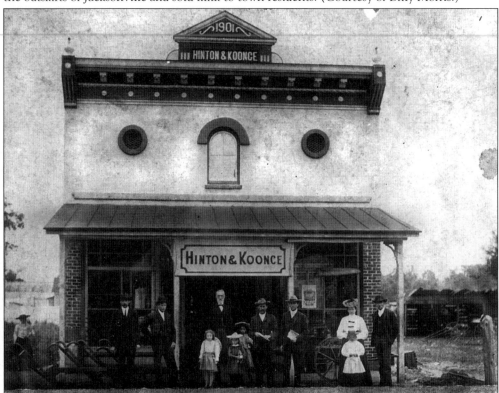

In 1901, the Hinton-Koonce Mercantile Store was the first brick store built on Court Street. This building later became the site of Ketchum's Drug Store. The people pictured here are unknown. (Courtesy of Marie Koonce Hinton Moore.)

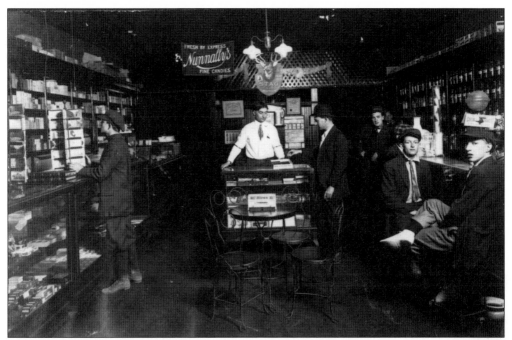

A 1912 photograph highlights Ward Loy Drug Store in Jacksonville. Pictured, from left to right, are Horace Thompson, Druggist H.M. Loy, Clarence Roten, Frank Bordeaex, Clayton Petteway, and Perry Morton (Courtesy of the Department of Archives and History, Raleigh.)

Sabiston Grocery on Court Street was a local business in the early 1900s. From left to right are Ed White, Will Brothers, Grady Whicker, Alvin Morton, Clyde Sabiston, Oleta Sabiston (at cash register), and an unknown clerk. (Courtesy of Jean Sabiston Schall.)

The Margolis family came to Jacksonville in 1912 and established a clothing store on Court Street. Members of the family seen here, from left to right, are Max, Fannie, Lottie, Leon, Bessie, Isaac, and Maurice. (Courtesy of Marilyn Margolis.)

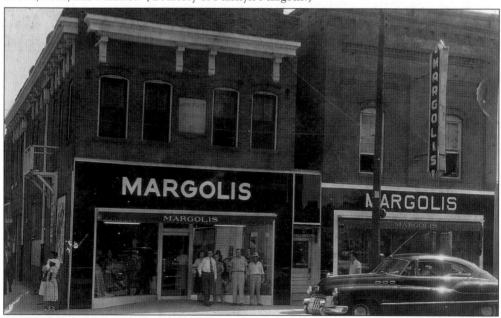

Max Margolis purchased the John Scott building on the corner of New Bridge and Court Streets in 1917, enlarging his original business. This store served the people of Jacksonville and Onslow County until 1978, when the business was moved to a new location. The business is now located in the Westwood Village Shopping Center. It has a new owner but operates under the same name. (Courtesy of Marilyn Margolis.)

18

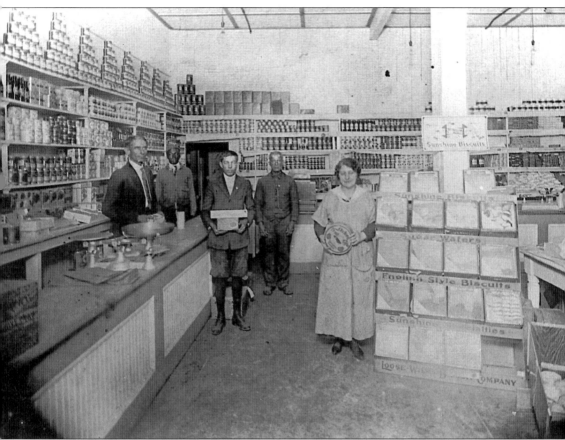

Brothers and Rivenbark Store is pictured at the corner of Court and New Bridge Streets in the early 1900s. This store was a large mercantile establishment that sold a great variety of things needed by the people in the village of Jacksonville. Here, one could buy groceries, fresh vegetables in season, household items such as lamps, lamp wicks, posts and pans, and sewing needs. The store was run by Mr. Will Brothers and Mr. ? Rivenbark. (Courtesy of the Onslow County Museum.)

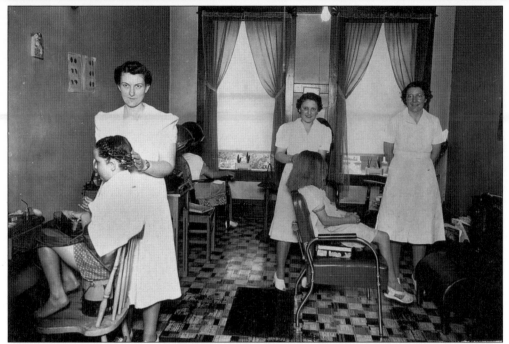

One of the first beauty shops in Jacksonville, this business was probably located opposite the courthouse and next to the Bank of Onslow in the 1930s. It was upstairs and a barber shop was downstairs. The workers are, from left to right, Mary Meadows, Romalda Aman, and Margaret Sewell. (Courtesy of Olese and Eloise Walton.)

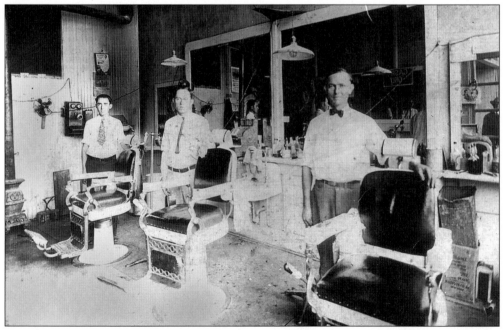

City Barber Shop, an important place to exchange information in Jacksonville, on Old Bridge Street is the subject of this 1925 photograph. The men pictured are, from left to right, Emory Greer Sr., Paul Marshburn, and George Allen Stanley. (Courtesy of Audrey Bridges.)

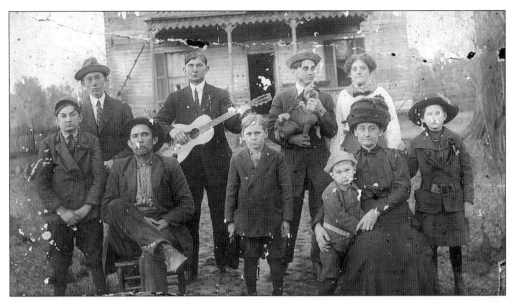

These photographs illustrate what houses in the area looked like, as well as the way people dressed, in the very early 20th century. Above, the Joe Ellis family lived in Jacksonville at the start of the 20th century. Jacksonville was then a farming community, and families in the surrounding area came to use the services offered by the businesses in the town. This family is dressed to go to church. (Courtesy of the Onslow County Museum.)

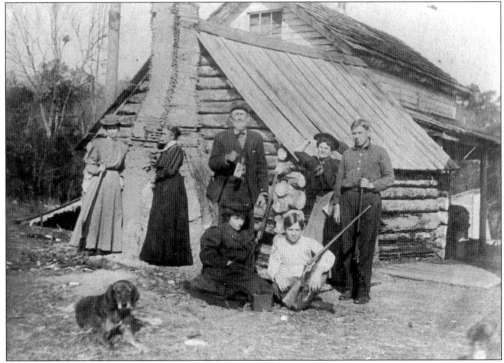

The Ward family is pictured here at Scales Creek near Jacksonville in 1900. The construction of this home is unique as the chimney is made of wood. This family has probably gathered for a reunion, and the men have probably been hunting. (Courtesy of the Onslow County Museum.)

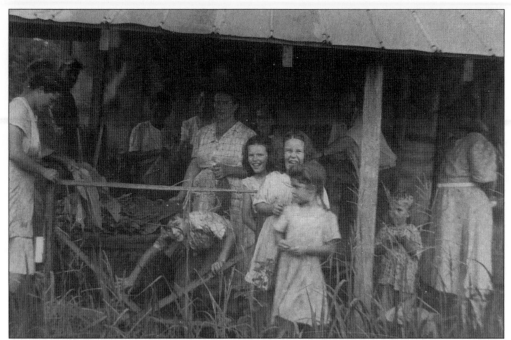

Many families in this area made their living by raising tobacco. This picture shows the Parker family preparing the tobacco for market. (Courtesy of Pat Blankenship.)

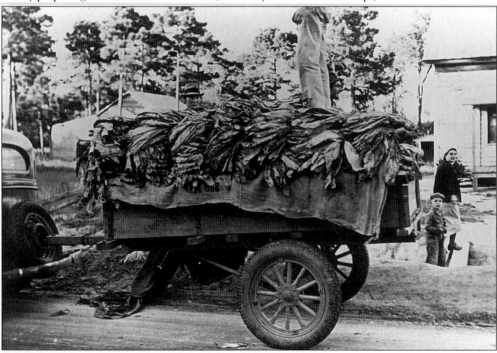

Tobacco is harvested and "cured" in a barn with heat for about a week. It is then graded for quality and prepared for transportation to the market. Pictured here is tobacco loaded on a trailer in Onslow County to be taken to the market in Kinston, a nearby town. (Courtesy of the Onslow County Museum.)

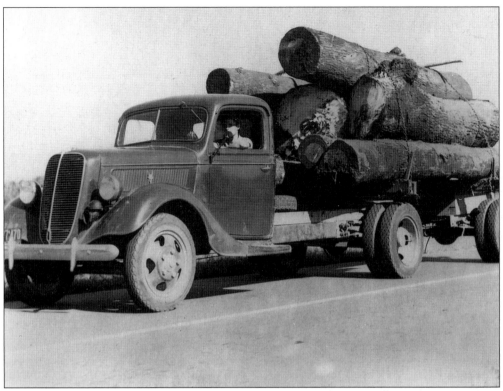

Trucks hauled logs to the lumber mill in Jacksonville. (Courtesy of the Department of Archives and History, Raleigh.)

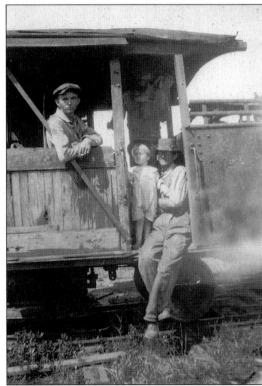

J.R. Avery and his family pose proudly in front of their logging locomotive. Most of the area surrounding Jacksonville was rugged, and trains, trucks, and log rafts were used to transport logs to the lumber mill. (Courtesy of Rex Avery.)

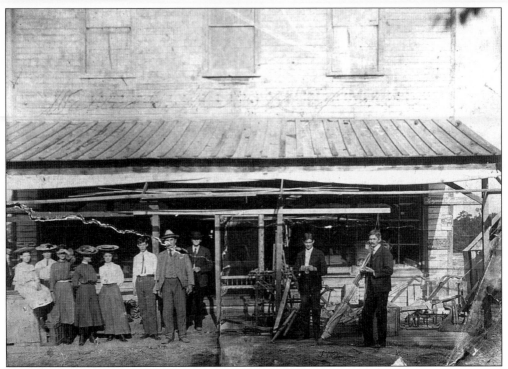

Numerous lumber companies were established in Onslow County in the 1890s and 1900s, namely Onslow Lumber Co., Jacksonville Lumber Co., Roper Lumber Co., and several others. It is not known which particular lumber company owned this headquarters building. The names of those pictured are unknown. (Courtesy of Judge Harvey Boney.)

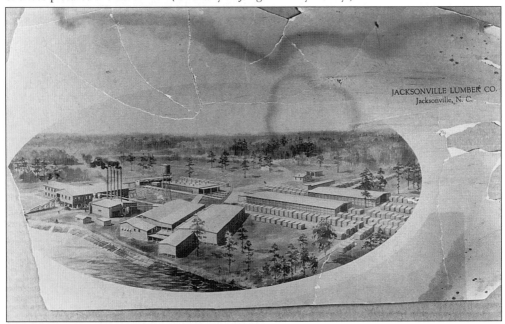

Jacksonville Lumber Company is shown in the early 1900s. Logs were transported to this lumber mill by trains, trucks, and log rafts. (Courtesy of the Onslow Cunty Museum.)

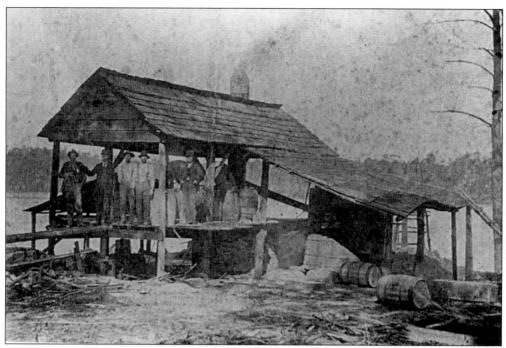

A turpentine still is pictured here in 1900. The longleaf pine was the source of resin, which was distilled to make turpentine—a very important naval stores product in shipping. A significant industry in Jacksonville and Onslow County, turpentine and other naval stores diminished in importance by World War I. (Courtesy of the Onslow County Museum.)

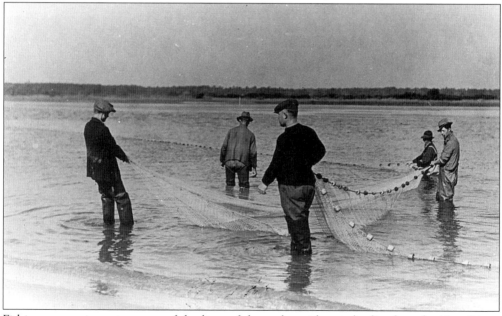

Fishing was an important part of the lives of the early residents who lived on the New River. Fish and other seafood items were of commercial value to local residents as well as a source of food for their families. The fishermen in this picture are at Brown's Inlet on the New River in 1930. (Courtesy of the Onslow County Museum.)

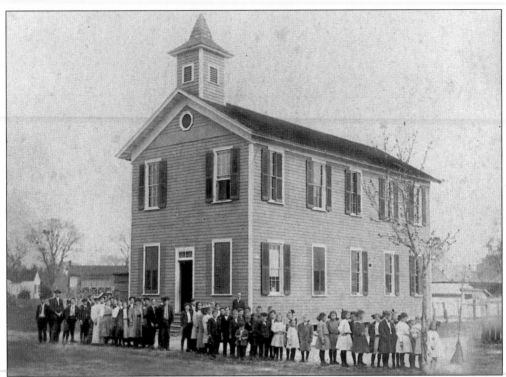

These children are standing in front of the Jacksonville Graded School in the early 1900s. All students from first grade through high school were taught in this building. (Courtesy of the Onslow County Museum.)

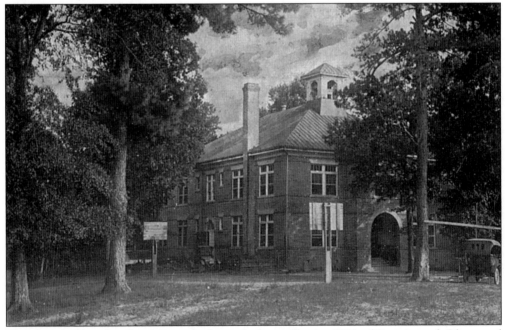

The first brick schoolhouse was built in Jacksonville in 1901. (Courtesy of Olese and Eloise Walton.)

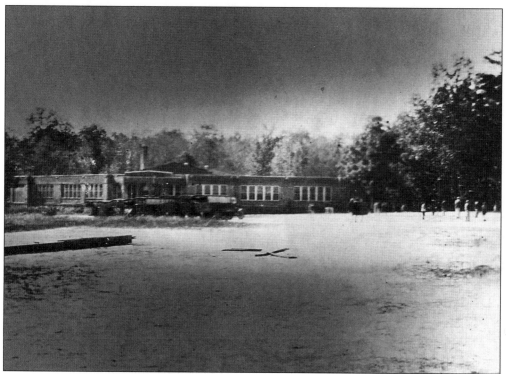

Pictured is the Jacksonville Graded School, which existed from 1925 to 1930. Grades one through seven were in the left wing and grades eight through eleven were in the right wing. The school was destroyed by fire in 1930 and was rebuilt. (Courtesy of Olese and Eloise Walton.)

The Graded School was replaced by a two-story structure in the early 1930s. Although called Jacksonville High School, it included grades one through eleven. It was also destroyed by fire— in 1940—and only the walls remained. The senior class held their graduating exercises at the Onslow Theater on Court Street. The school was rebuilt using the existing walls and is now the New Bridge Middle School. (Courtesy of Cris Koonce.)

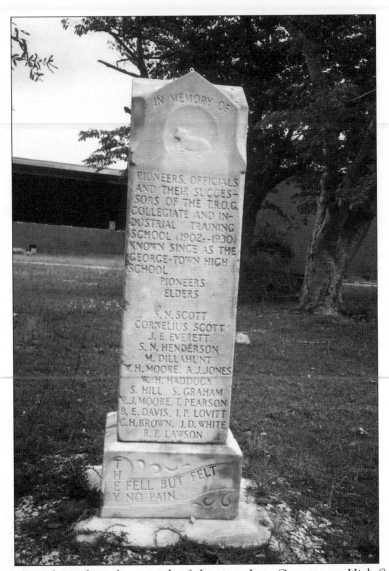

This monument is located on the grounds of the site where Georgetown High School once stood. The only high school for African Americans in Onslow County, Georgetown was founded by the Trent River Oakey Grove Missionary Baptist Association in 1902. It opened as the Trent River Oakey Grove Collegiate and Industrial Training School, under the principalship of William Washington Parker, and was a private, non-sectarian boarding school. The funds for its operation were dependent upon student tuition and private sources that included teachers, the Parent-Teachers Association, and Dr. William Sharpe, a white neurosurgeon from New York who made generous contributions to the school. Control of the school was transferred to the county in 1919, but it got little public support until 1930. The school's name was changed to the Georgetown School and it boasted an elementary and high school complex. J.W. Broadhurst was principal in 1937. Georgetown later became the first high school in Onslow County to be accredited by the Southern Association of Colleges and Secondary Schools. The school closed in 1966 as the result of desegregation. Shortly afterwards this building was occupied by the Onslow County Industrial Education Center, which later became Coastal Carolina Community College. (Photo by Dr. Stratton C. Murrell.)

The George Bender House at 215 Mill Avenue was built in 1901 by J.F. Boggs for his daughter Mary, who married Dr. George Bender. Many of Jacksonville's old homes are located on Mill Avenue. (Photo by Dr. Stratton C. Murrell.)

The Farnell House at 311 Mill Avenue was built in 1910 and stands beside the Old Methodist Church, which is now used as the headquarters for Onslow County's Council on Aging. (Photo by Dr. Stratton C. Murrell.)

Built in 1910 on the banks of New River, the Hitch House is located at 17 Bluff Street. (Photo by Dr. Stratton C. Murrell.)

The Steve Aman House at 405 Mill Avenue was built in 1925 by Gudgie Brown and Luthur Hardison. (Photo by Dr. Stratton C. Murrell.)

Constructed in 1900, the Samuel Ambrose House stands at 301 Mill Avenue. (Photo by Dr. Stratton C. Murrell.)

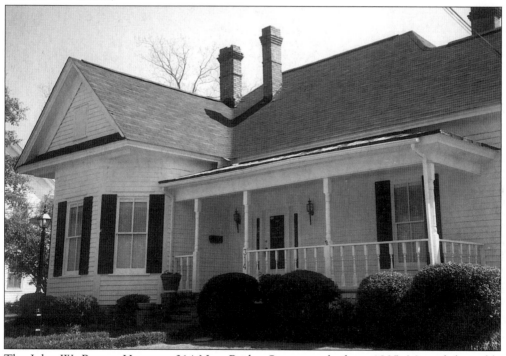

The John W. Burton House at 314 New Bridge Street was built in 1905. Many fashionable houses were built on this street during the early 1900s. (Photo by Dr. Stratton C. Murrell.)

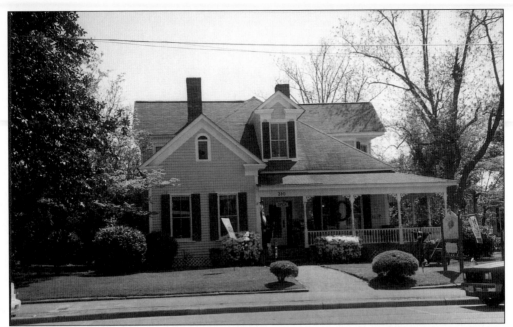

Located at 310 New Bridge Street, the R.P. Hinton House was the first house built on New Bridge Street in 1903. Mr. Hinton came to this area as an engineer for Thomas McIntyre, who built the Wilmington, Onslow and East Carolina Railroad. Hinton became a successful merchant and was the mayor of Jacksonville in 1914. (Photo by Dr. Stratton C. Murrell.)

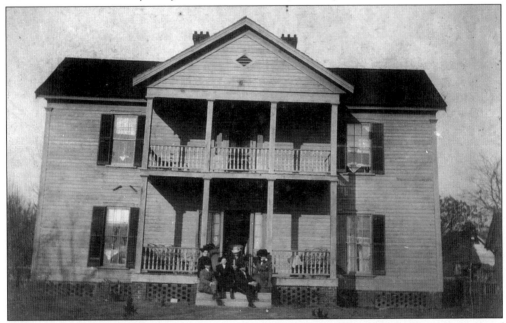

Built in the late 1800s, the Murrill house was situated on Murrill's Circle at the intersection of Court Street and Highway 17 South. Charles Warn, mayor of Jacksonville from 1938 to 1944, lived in this house at the time that Camp Lejeune was being constructed. In the 1960s, the structure was moved to Mildred Avenue where it stands today and is used as a Catholic rectory. (Courtesy of John D. Warlick.)

The Jarman Hotel, located across from the train depot at 101 Railroad Street, provided lodging for many visitors who came to Jacksonville. Mr. Jarman also owned a livery stable on Mill Avenue that provided transportation for hotel guests and others who visited Jacksonville and Onslow County in the 1890s. (Photo by Dr. Stratton C. Murrell.)

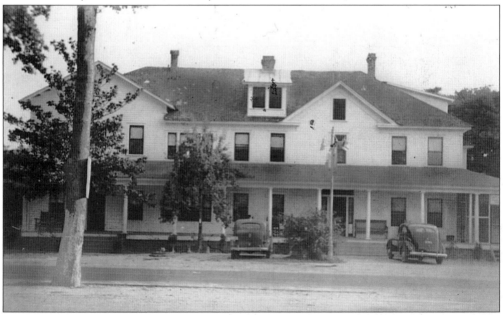

The Riverview Hotel was owned by Georgie and Hill Humphrey. It is said that the food served at this hotel was the best in town. The hotel was patronized by many people outside of Onslow County as well as the locals and was situated at the intersection of Old Bridge and Anne Streets, near what is now the Jerry J. Popkin Bridge. (Courtesy of Jerald "Scotty" Humphrey.)

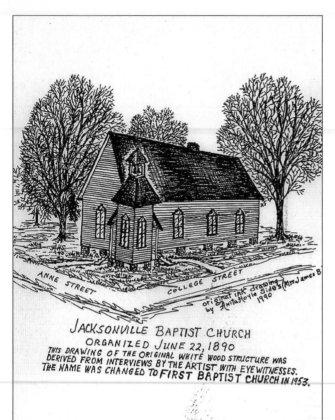

The Jacksonville Baptist Church, built in 1890, on Anne Street was the first church building constructed for a specific congregation in Jacksonville. The building stood until 1934, at which time it was moved to a location in the Nine Mile section of the county and renovated. It became the Bethany Baptist Church. (Courtesy of the Jacksonville First Baptist Church Historical Collection.)

JACKSONVILLE BAPTIST CHURCH
ORGANIZED JUNE 22, 1890
THIS DRAWING OF THE ORIGINAL WHITE WOOD STRUCTURE WAS DERIVED FROM INTERVIEWS BY THE ARTIST WITH EYE WITNESSES.
THE NAME WAS CHANGED TO FIRST BAPTIST CHURCH IN 1953.

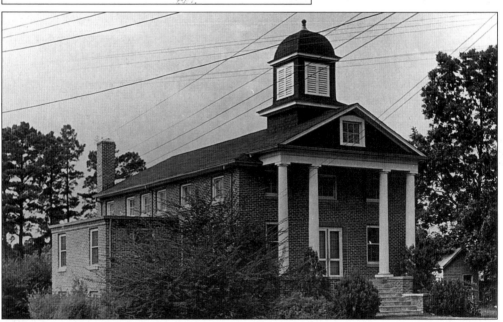

The Jacksonville Baptist Church is depicted here in the 1930s. This structure was used until 1951, when a new church was constructed at the same location. (Courtesy of the Onslow County Museum.)

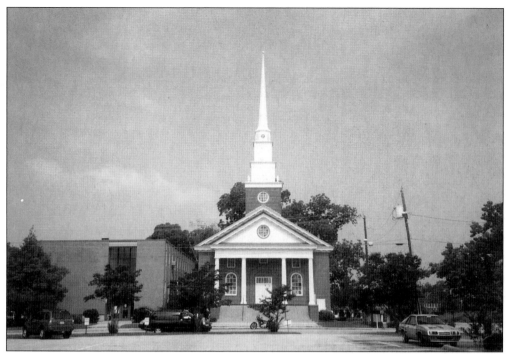

The First Baptist Church has undergone many renovations since 1951, but even with all of the additions, it is no longer large enough to serve the needs of the greatly expanded congregation. (Photo by Dr. Stratton C. Murrell.)

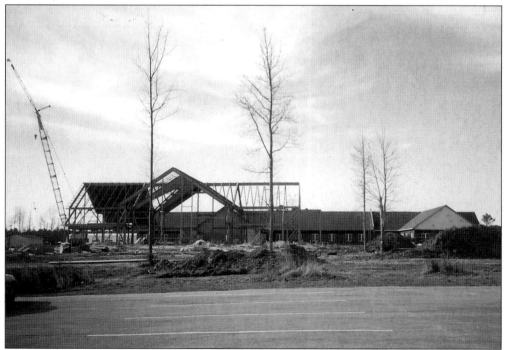

Construction of the First Baptist Church at its new location on the Gum Branch Road is shown in 2001. (Photo by Dr. Stratton C. Murrell.)

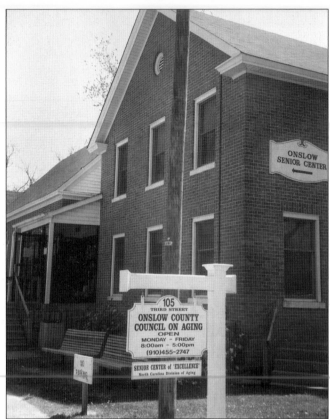

Trinity Methodist Church, built in 1894 on Mill Avenue, was the second church built in Jacksonville. This building is now used as the headquarters for the Council On Aging. (Photo by Dr. Stratton C. Murrell.)

In May 1956, the congregation of Trinity United Methodist Church moved from Mill Avenue to the present location on Highway 17 South near Onslow Inn. (Photo by Dr. Stratton C. Murrell.)

The Lockomy House, located at 108 Mill Avenue, has been the home of the W.C. Chadwick family since the 1930s. Ninety-five-year-old Mrs. Geneva Chadwick is a very knowledgeable source of the history of Jacksonville. (Photo by Dr. Stratton C. Murrell.)

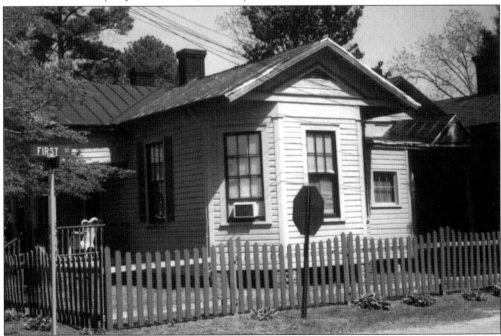

The Richard Ward House at 200 Mill Avenue was built in the 1890s. Dr. Ward was instrumental in the development of Mill Avenue, where many of the residents brought into town by lumber companies and railroads built their homes. (Photo by Dr. Stratton C. Murrell.)

This plank road was located near Jacksonville; there were a few plank roads for logging trucks. The only paved street in Jacksonville in the early 1900s was Highway 30, which is now Old Bridge Street. The roads and bridges in Onslow County were of poor quality and would remain so for many years. (Courtesy of the Onslow County Museum.)

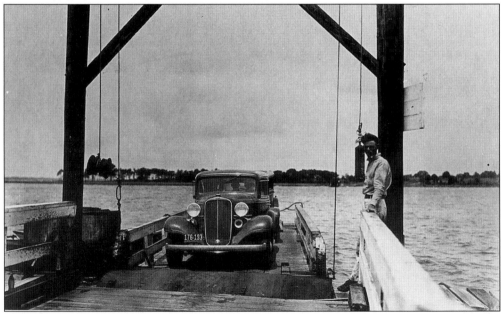

The last operational ferry to transport cars and passengers in Onslow County went from Sneads Ferry to what would become Marine base property. A steel drawbridge replaced the ferry in 1939. The roads improved with the creation of the State Highway Commission and the Congressional passage of the Federal Aid Road Act in 1916. (Courtesy of the Onslow County Museum.)

The Onslow Rod and Gun Club is the subject of this 1930 photograph. Several similar clubs existed in Onslow County and attracted many sportsmen from the East Coast. One of the most outstanding of these was Dr. William Sharpe, a neurosurgeon from New York, who loved this area and invested much time and money in it. He was a major contributor to the development of the first organized technical and academic opportunities for African Americans in this county. Some of his property was taken for use by the military base and some of it remains today as the Hammocks Beach area, a state park. This park is enjoyed by both residents and tourists. (Courtesy of the Onslow County Museum.)

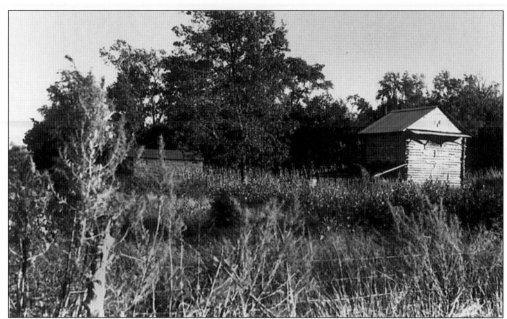

An old tobacco barn of the 1930s is shown on property that was taken over by the U.S. Marine base. (Courtesy of the Department of Archives and History, Raleigh.)

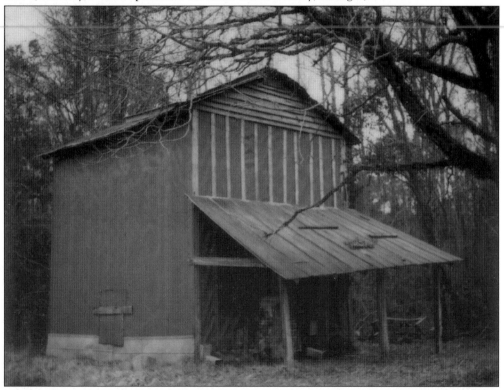

This is a more modern tobacco barn found in Onslow County in the late 1940s, when farmers raised tobacco and were also employed as civil service workers at Camp Lejeune. (Photo by Mark S. Murrell.)

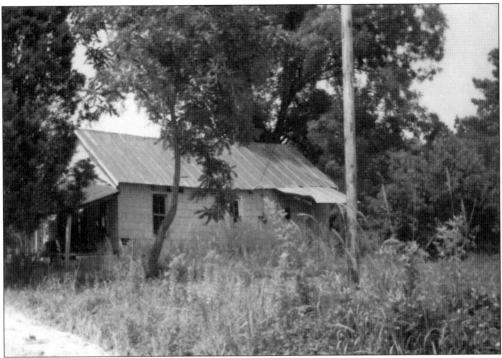

Pictured here is the homeplace of the Parker family in the late 1940s. It was located on the Gum Branch Road, which was only a dirt road at that time but was was paved in the 1950s. (Courtesy of Pat Blankenship.)

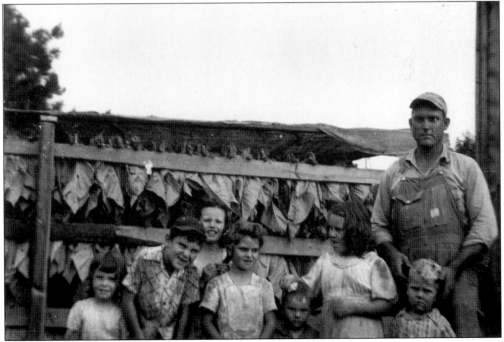

Tobacco preparation is shown on the Parker Farm in Onslow County. (Courtesy of Pat Blankenship.)

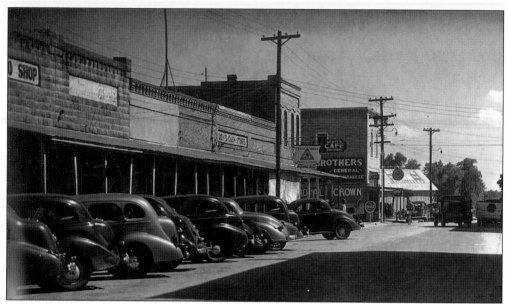

In this 1937 view, Court Street is lined with automobiles parked in front of the businesses across from the Bank of Onslow. Pictured are Margolis Men's Store, Kechum's Drug Store, Miss Jenny's 5¢ and 10¢ Store, Petteways Grocery Store, Aman's Hardware Store, and at the very end of the street, A.G. Walton's Coal and Ice Company. Many people came to town to shop on Saturdays. (Courtesy of Marilyn Margolis.)

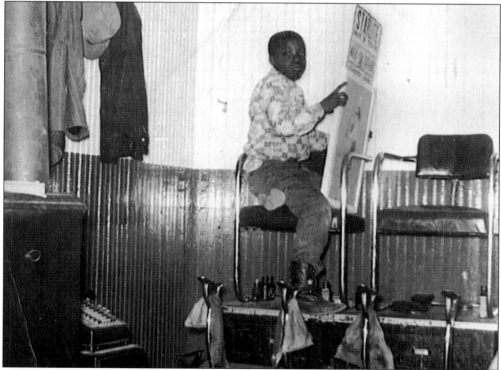

Get your shoes shined here before going to court! Emory Greer's Barber Shop offered shoe-shining services. (Courtesy of Audrey Bridges.)

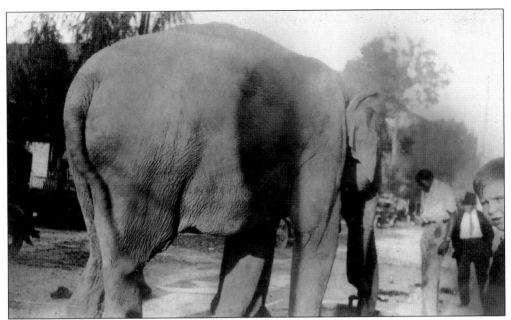

The circus is coming to town! An elephant is being watered at the artesian well on Mill Avenue in the 1930s. Joe Henderson is pictured in the foreground. (Courtesy of John D. Warlick.)

Mill Avenue appears in this 1930s photograph, when it was a dirt street and had only 10 to 12 homes located on it. An artesian well was situated in the center of the street, which ended near the river. This is now part of the historical district of Jacksonville. (Courtesy of John D. Warlick.)

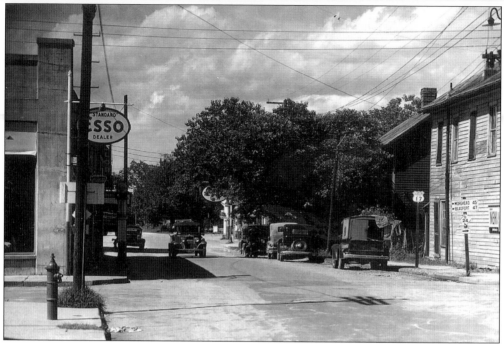

Visible in this 1930s photograph of the intersection of Court and New Bridge Streets in the 1930s is the Esso Dealer sign on Highway 17. (Courtesy of Marilyn Margolis.)

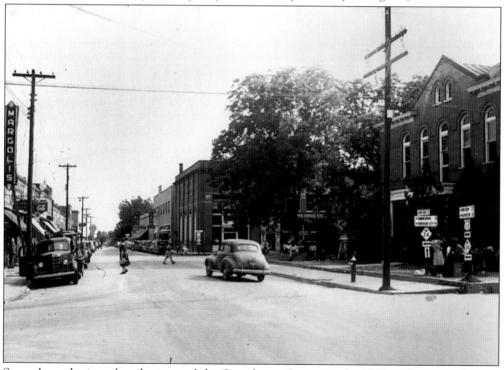

Several people sit on benches around the Courthouse Square in the 1930s—this was a favorite gathering place. (Courtesy of the Department of Archives and History, Raleigh.)

Two

JACKSONVILLE
A TWENTIETH-CENTURY
BOOMTOWN

In 1939, Col. George W. Gillette was in charge of the U.S. Army Corps of Engineers in Wilmington, North Carolina. His detachment surveyed and mapped the coast of North Carolina and he drew a map, which was labeled "The Unguarded Coastline" and distributed to national defense departments. This action would change Colonel Gillette's personal destiny as well as that of Jacksonville and Onslow County. Colonel Gillette planned to retire at his home in the village of Marines on Courthouse Bay in Onslow County. When the U.S. Navy saw this map, they decided that Onslow County was the place to establish a base for amphibious training. Congressman Graham Barden of New Bern, North Carolina helped convince Congress that the necessary funds should be appropriated for the construction of this base. Part of the land confiscated for its construction included Colonel Gillette's homeplace, and he was forced to retire elsewhere.

On February 15, 1941, Congressman Barden announced that a 100,000-acre site in Onslow County had been chosen and approved for the construction of one of the largest Marine Corps bases in the United States. Land acquisition began almost immediately. The quiet, uncomplicated way of life in the area would change forever when the 1st Marine Division set up camp in the middle of a sandy pine thicket on the coast of Onslow County in North Carolina.

Many families in the county would be displaced from the land they had owned for years, and many were left with no place to go. Over 700 families were displaced, and in many cases the money they received from the government for their property was not enough to buy a comparable home.

Jacksonville, North Carolina became a boomtown but had limited services and resources to meet the needs of the sudden population explosion. World War II was heating up in Europe, and with the Japanese attack on Pearl Harbor, the United States would be a nation at war. Hard work, patriotism, and cooperation helped Jacksonville citizens overcome hard times. The town and Marine base fulfilled a strategic national need.

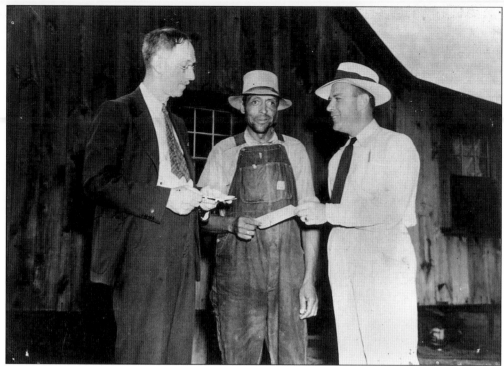

Nere Day (left), an attorney for the Marine base in charge of land transactions between the federal government and private citizens, presents a check to Lonnie Spicer for the first land purchase for the construction of Camp Lejeune. Walter Jones observes the transaction. (Courtesy of the North Carolina Collection, University of North Carolina Library at Chapel Hill.)

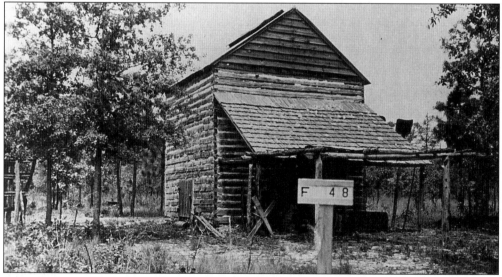

A sign in front of this tobacco barn denotes that the property had been surveyed and was part of the Camp Lejeune land acquisition by the U.S. government. Approximately one-fifth of the land area of Onslow County was taken for use as a Marine base. (Courtesy of the Onslow County Museum.)

46

A 2001 photograph captures Sam Starling's Livery Stables on New Bridge Street. Many modifications have been made to this building and this area since 1941, but this part of the building still remains. A detachment of Marines used the stables as their headquarters while surveying the land that would eventually be Camp Lejeune. (Photo by Dr. Stratton C. Murrell.)

First Marine Headquarters in 1941 was a converted farmhouse that belonged to the Gurganus family and was located off Highway 17 South in the vicinity of what is now Camp Geiger. It was referred to as Marine Barracks at New River. (Courtesy of the Onslow County Museum.)

This young military bride of 1941 represents the many young married couples who came to town during WW II. There was no housing in Jacksonville except hurriedly constructed places, usually consisting of one room and a shared bath facility. A few couples were lucky enough to find a room in a private home or a small trailer. (Photo by Dr. Stratton C. Murrell.)

A line of one-room dwellings was typical of most of the housing found in Jacksonville in the early 1940s. After WW II these apartments were moved to Swansboro and converted into a summer vacation house on the White Oak River. The structure was torn down in the 1990s. (Photo by Dr. Stratton C. Murrell.)

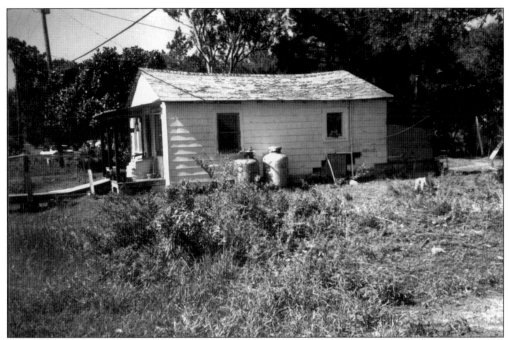

One of the first houses built in Kellumtown in the 1940s still stands today. Many African Americans whose property was acquired for the Marine base were left with no place to go and were not given enough money to buy another farm. After much hardship, they were able to move across the highway and acquire property from Raymond Kellum; they then built the community of Kellumtown. (Photo by Dr. Stratton C. Murrell.)

The First Baptist Church of Kellumtown was built in 1941, and the Reverend B.G. Washington was the pastor from 1941 to 1943. The church was one of the first buildings of large size built in Kellumtown and is located on Kellumtown Road. (Photo by Dr. Stratton C. Murrell.)

Hettie Lucinda Ward's house is one of the many in Kellumtown. Ward graciously shared information, including newspaper stories and photographs, for inclusion in this volume. Her input helped in understanding of the hardships endured by the people who were forced to move off their farms and away from their homes. (Photo by Dr. Stratton C. Murrell.)

The home of William Chadwick is pictured here in Kellumtown. He was "mayor" of this community when it was developed in the 1940s. Chadwick was chosen by the people of Kellumtown to be their spokesman during the time when so many African Americans were displaced due to the U.S. government's land acquisition. (Photo by Dr. Stratton C. Murrell.)

Billy Arthur founded *The Onslow County News and Views* in April 1940, and the office was located on New Bridge Street. The masthead of his paper read, "The Only Newspaper In The World That Gives A Whoop About Onslow County." (Courtesy of the Department of Archives and History, Raleigh.)

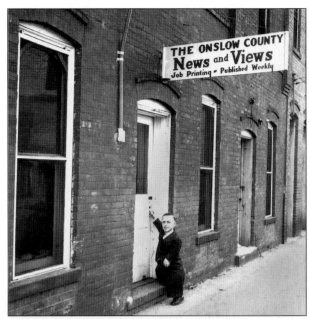

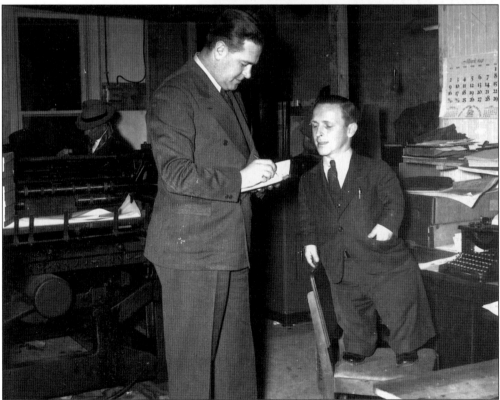

Above, Billy Arthur discusses the next issue of *The News and Views*. Arthur later became a member of the North Carolina State Legislature in 1945. At the present time, Billy lives in Chapel Hill and still writes articles for *Our State* magazine. (Courtesy of the Department of Archives and History, Raleigh.)

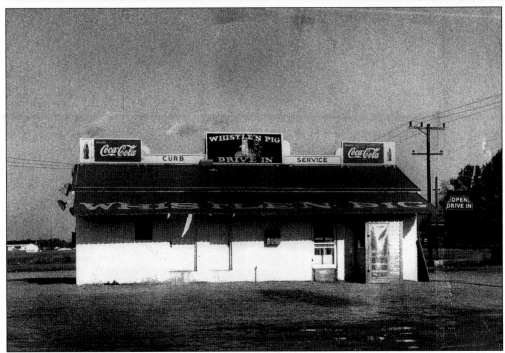

The Whistle'n Pig Drive-In represents the many eateries offering curb service in the 1940s. These drive-ins were much different from the "drive up window" services of today. (Photo by Joe Bynum.)

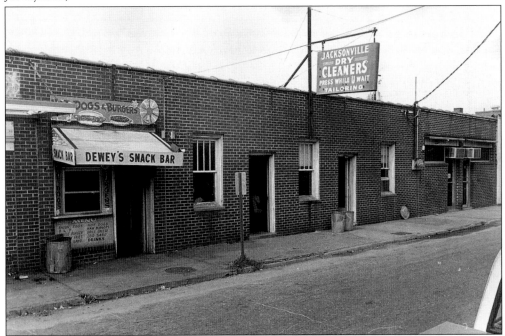

Dewey's Snack Bar was located on Court Street and offered indoor seating. Many snack bars, as well as bars and grills, could be found on Court Street. On weekends, many young Marines came to town on buses that brought them from Camp Lejeune.

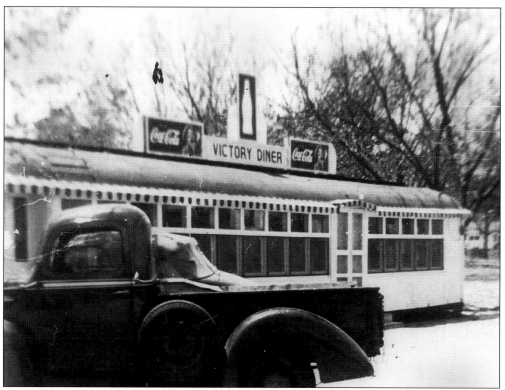

The Victory Diner on New Bridge Street served plate lunches and was actually a converted railroad dining car. (Courtesy of Thelma Langley.)

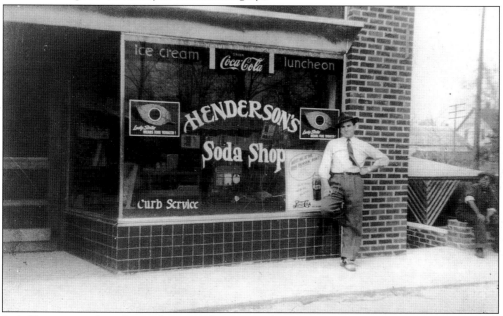

Jack Koonce stands in front of Joe Henderson's Soda Shop, built in 1943 on Old Bridge Street. Many snack bars, soda shops, bars and grills, and some restaurants were built in the downtown area during the 1940s. In 1943 curb service was offered by this shop. (Courtesy of Cris Koonce.)

Many stores were rapidly constructed in the 1940s to take care of the needs of the townspeople. The Popkin family built Boom Town Grocery Store at Holly Ridge, where Camp Davis was located. The Popkins also built a Boom Town Furniture Store in Jacksonville in the early 1950s. The Popkin family still owns and operates the furniture store in Jacksonville. (Photo by Dr. Stratton C. Murrell.)

A 1941 photograph depicts Arthur Langley's Mercantile Store on New Bridge Street. Note the pump handle on the gas tanks in front of the store. Lois Aman (left) and Patsy Langley stand beside the store. (Courtesy of Thelma Langley.)

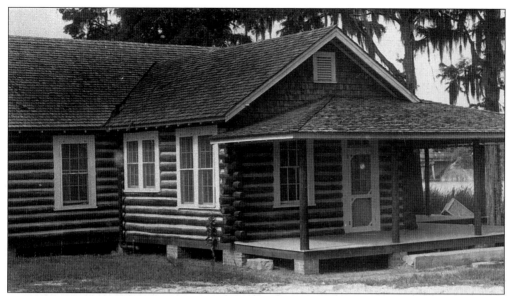

The Works Progress Administration (WPA) built Pine Lodge in the early 1930s; it was used by residents as a recreation center. The Marine Corps personnel also used Pine Lodge until the United Service Organization (USO) building was constructed and dedicated in 1942. (Courtesy of Thelma Langley.)

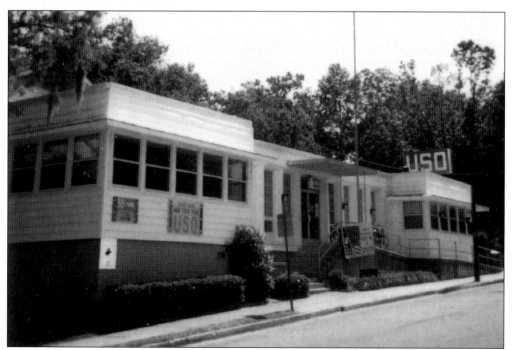

The USO building is located at 9 Tallman Street. The National USO was founded as a federation of six volunteer agencies, which coordinated a program whereby civilians could serve the educational, social, and spiritual welfare needs of members of the armed forces. It just so happened that this organization was formed at about the same time that the Marine Corps base was established in Onslow County. (Photo by Dr. Stratton C. Murrell.)

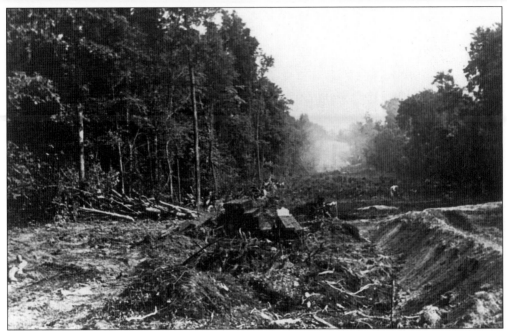

On April 15, 1941, construction began for the Marine Corps Training Center at New River. The base was carved out of virtual wilderness. A few dirt roads and cleared farms existed but most of the land had to be cleared before the building of roads, bridges, or buildings could begin. The cost of the land totaled $1.5 million. (Courtesy of the Onslow County Museum.)

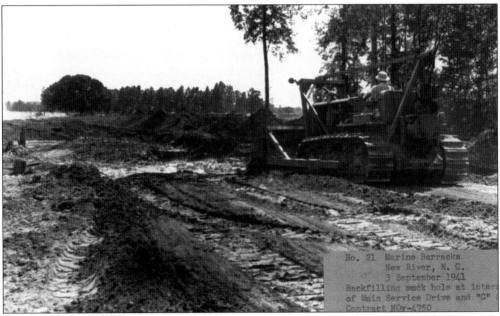

The building continues in September 1941, and heavy equipment was brought in to do the work of clearing land and constructing roads. Workers had to overcome the problems presented by pine forests, deep sand, and marshes. Added to these problems were the summer heat, humidity, and insect bites. (Courtesy of the Graphics Department, Marine Corps Base, Camp Lejeune.)

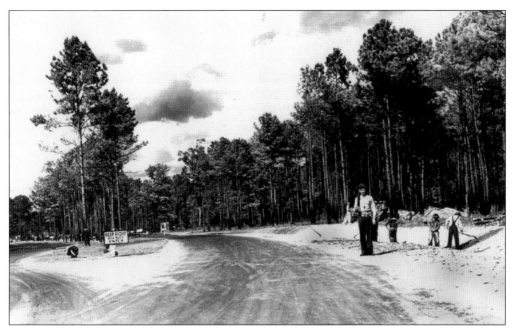

The entrance to the Marine base begins to take shape after much planning and work by surveyors, engineers, and construction workers. This is the main gate in 1941. (Courtesy of the Graphics Department, Marine Corps Base, Camp Lejeune.)

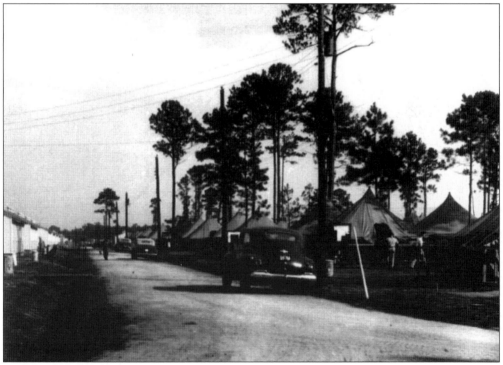

The Marine Barracks on D Street is pictured in September 1941, housed under canvas. Permanent barracks were still under construction. (Courtesy of the Graphics Department, Marine Corps Base, Camp Lejeune.)

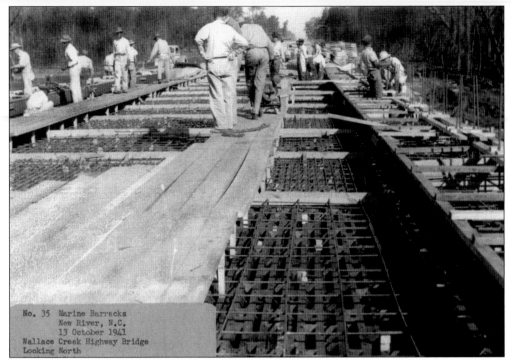

The Wallace Creek Highway bridge is seen here during construction in the fall of 1941. Much progress has been made since April 1941, when the building of the Marine base began. (Courtesy of the Graphics Department, Marine Corps Base, Camp Lejeune.)

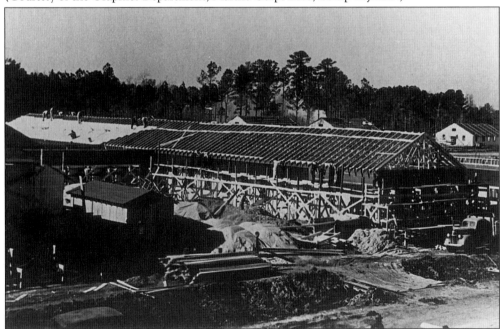

A permanent barracks is under construction in 1941. These buildings along with many others were ready for use by December 1942. The first stage of the building of Camp Lejeune was completed by September 30, 1942. (Courtesy of the Onslow County Museum.)

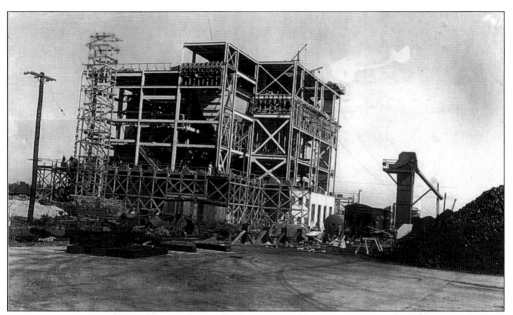

Construction of a steam plant for heat and energy production was critical. A temporary plant consisted of two modified boilers from steam locomotives, but the construction of a permanent plant began in 1942 under the supervision of Navy engineer William T. Harding of Raleigh. (Courtesy of Mary T. Parker, Mr. Harding's granddaughter.)

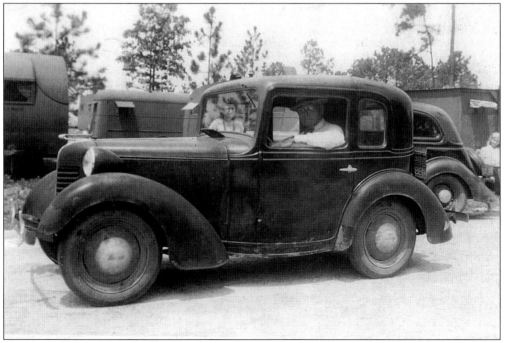

Harding is shown in his Bantam car, near his trailer marked with an arrow. (Courtesy of Mary T. Parker.)

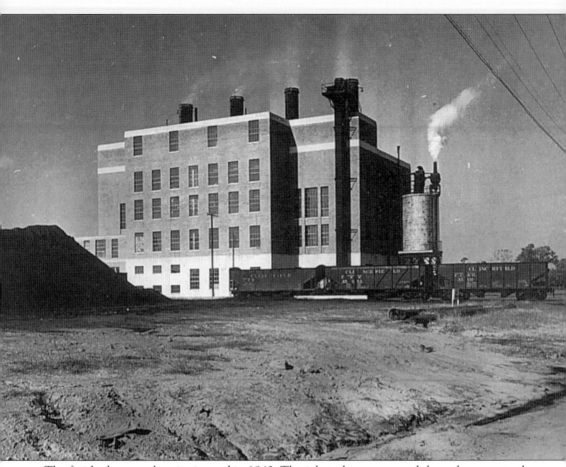

The finished steam plant is pictured in 1943. The job took one year and three days to complete at a cost of $2.5 million. It has since been enlarged and brought into the computer age and is known affectionately as "The Lady" by the devoted men who keep her up and running. (Courtesy of Mary T. Parker.)

These bridges cross the New River. The bridge at the top of the picture was built in 1926 and carried the people into the business district of Jacksonville. The lower bridge was built in 1943 as a Jacksonville by-pass to take care of heavy traffic generated by the building of Camp Lejeune. (Photo by Joe Bynum.)

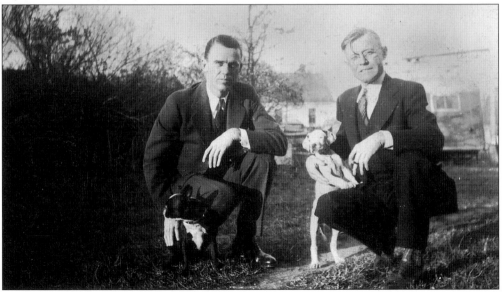

Ray E. Koonce Sr. (left) and Edgar P. Koonce (right) were brothers and district engineers. Ray was the engineer in charge of building the 1926 bridge that went into the business district of Jacksonville. Edgar was the engineer in charge of building the by-pass bridge on Highway 17. (Courtesy of Marie Hinton Koonce Moore.)

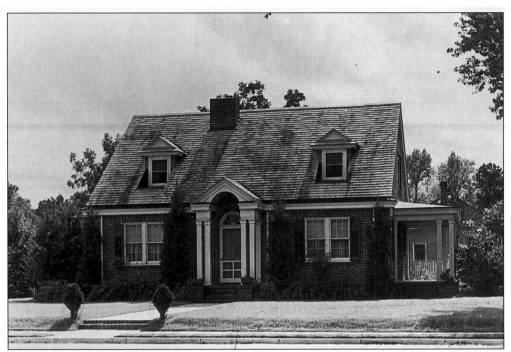

Constructed in 1931, the W.L. Ketchum House was the first brick home built in Jacksonville. Ketchum owned Ketchum's Drug Store. Carl Winter was the pharmacist at Ketchum's Drug Store for many years. (Courtesy of the Onslow County Museum.)

The R.R. Tallman House was the second brick house built in Jacksonville. (Courtesy of Donald Tallman.)

These homes on Chaney Avenue in 1938 illustrate the varied architecture in the area in the 1920s and 1930s. The homes still stand today. (Courtesy of the Onslow County Museum.)

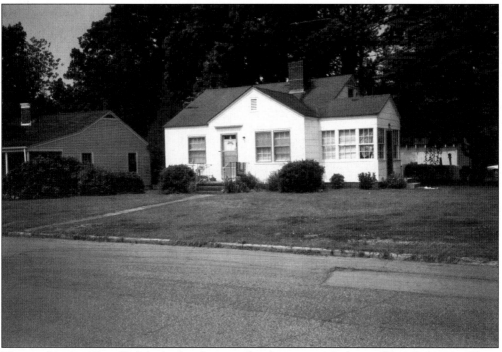

This is a house in Pine Ridge, the first housing development in Jacksonville in the 1940s. These homes were built on the T.B. Koonce farm on Wilson Bay, marking the beginning of permanent homes for civilian and military personnel living in Jacksonville. (Photo by Dr. Stratton C. Murrell.)

Duplex apartments were built in the New River Housing Development in the late 1940s. Most of these apartments were leased to the government for military personnel and their dependents. Civilian personnel lived elsewhere, many commuting a distance of 30 miles or more from their homes to work on the base or in Onslow County. (Photo by Dr. Stratton C. Murrell.)

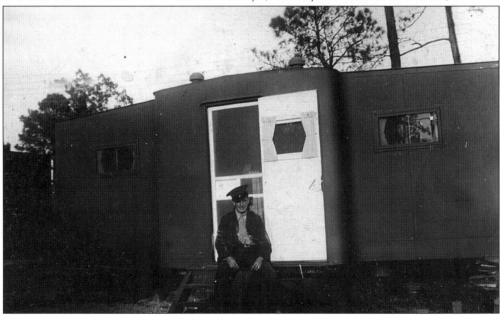

Many military personnel and their dependents lived in small trailers such as this one until better housing was available. These structures had no air conditioning and few windows. (Courtesy of Pearl Christenson.)

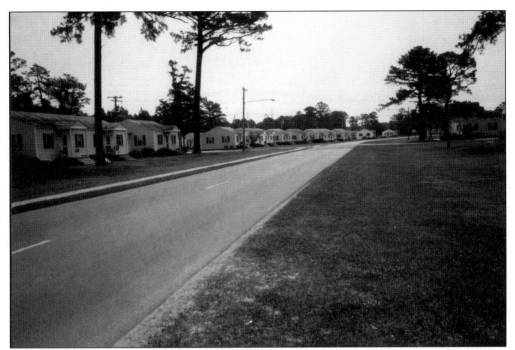

Federal housing for military personnel in the late 1940s was located at Midway Park, which is close by the main gate of Camp Lejeune. Most of these homes were built in the 1940s. (Photo by Dr. Stratton C. Murrell.)

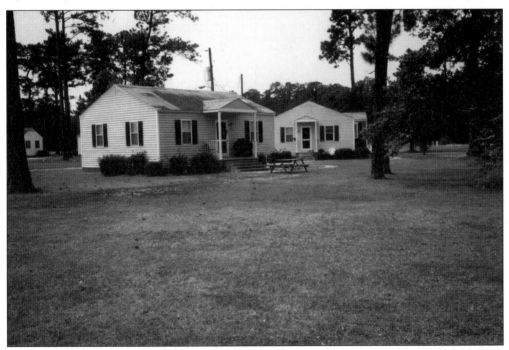

Here is a closer view of Midway Park housing. These houses are well maintained and this is how they appear in the year 2001. (Photo by Dr. Stratton C. Murrell.)

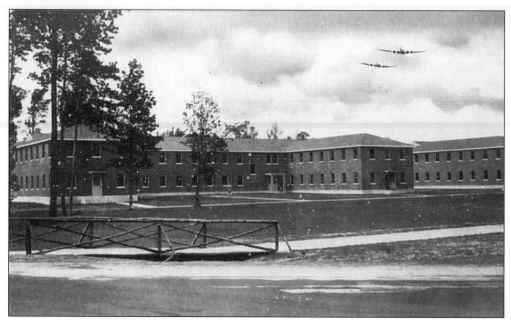

In the 1940s most of the permanent barracks had been completed for military personnel. The cost to build Camp Lejeune was $15 million, but this did not include the cost of the land acquired by the U.S. government. (Courtesy of the Department of Archives and History, Raleigh.)

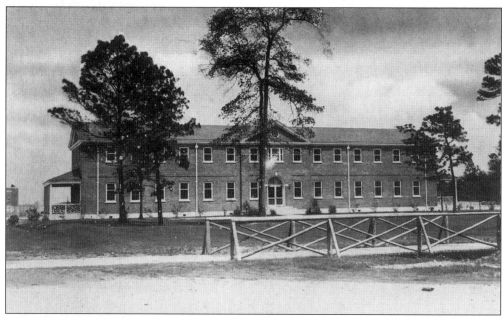

A Hostess House was located on the Marine Base. This was a large "home away from home" for those who came to visit their loved ones stationed at Camp Lejeune. There were no motels in Jacksonville until the 1950s. (Courtesy of the Department of Archives and History, Raleigh.)

Dr. H.W. Stevens was the director of the Onslow-Pender Health District. He lived in Jacksonville but worked at branch offices and clinics in Burgaw, Richlands, Holly Ridge, and Camp Lejeune, as well as Jacksonville. The first public health clinic in Jacksonville was located over the Double Eagle Bar and Grill on Old Bridge Street. "Mexicali Rose" was a popular song that could be frequently heard in the clinic! (Courtesy of Naomi Cardwell.)

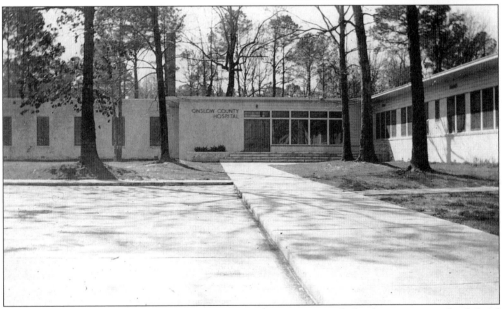

Onslow County got its first hospital in 1943. Dr. H.W. Stevens helped to convince the federal government to erect this hospital, which was subsequently turned over to the county. The Onslow County Public Health Department was located in a wing of the hospital after it was built. (Courtesy of Naomi Cardwell.)

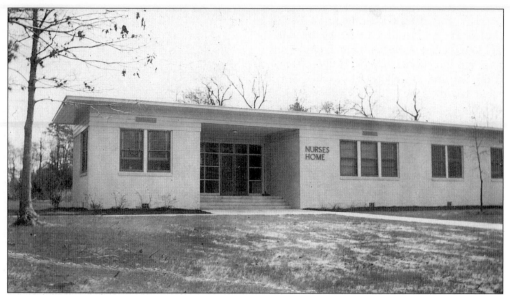

The Nurses Residence was referred to as the "Nurses Home" in 1944. This building was the living quarters for registered nurses employed by Onslow County Hospital. (Courtesy of Naomi Cardwell.)

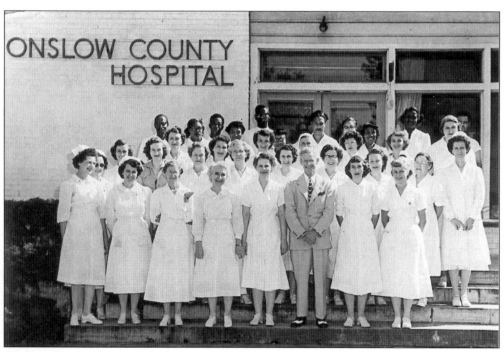

Onslow County Hospital had a staff of 37 people in 1948. (Courtesy of the Onslow County Museum.)

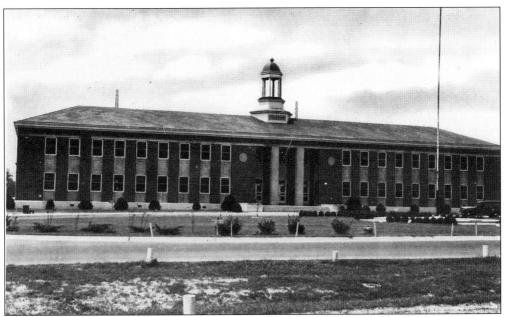

An administrative building at Camp Lejeune was completed in the early 1940s. (Courtesy of the Department of Archives and History, Raleigh.)

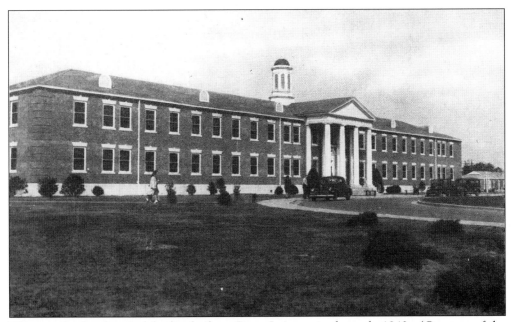

This was the first hospital facility built at Camp Lejeune in the early 1940s. (Courtesy of the Department of Archives and History, Raleigh.)

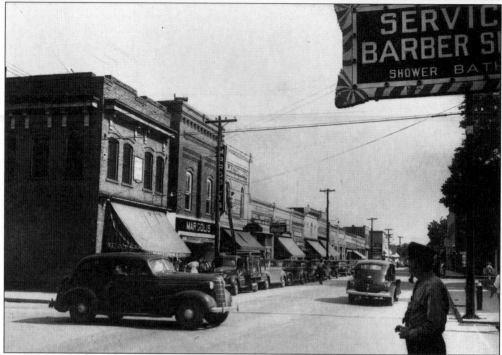

The town grew to accommodate the tremendous influx of people. In the foreground of this 1940s picture of Court Street, the Service Barber Shop advertises shower and bath facilities. (Courtesy of the Department of Archives and History, Raleigh.)

Highway 24 from Jacksonville to the main gate of Camp Lejeune soon became lined with many business establishments. Many of the original businesses are still on this highway. (Courtesy of Katherine Pace.)

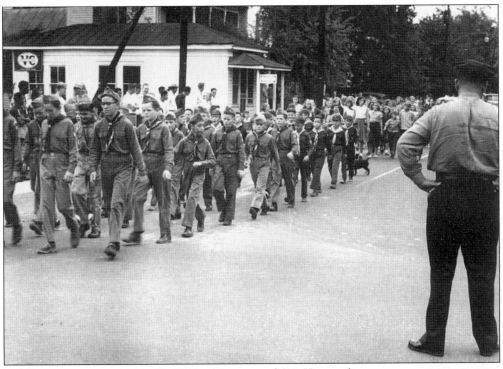
Boy Scouts are on parade in the 1940s. (Courtesy of Cris Koonce.)

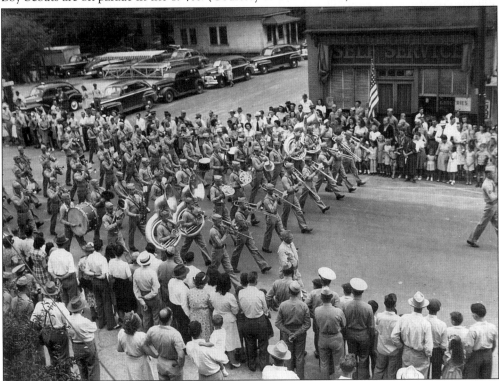
The Marines parade down Court Street in the 1940s. (Photo by Dr. Stratton C. Murrell.)

Billy Arthur and his friends at the Kiwanis Club prepare to go deep-sea fishing in 1949. Arthur said that he came to Jacksonville to go fishing and ended up being the editor and publisher of *The News and Views* newspaper. Billy is the first person on the left on the front row. (Courtesy of Donald Tallman.)

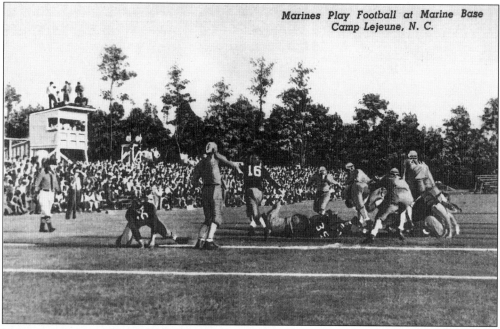

Marines are pictured here playing football at Camp Lejeune in the 1940s. (Courtesy of the Department of Archives and History, Raleigh.)

Three

GREAT GROWTH
AND STRENGTH

The last half of the 20th century was a time of great change for the land and the people. A huge military base rose up out of the marshes, pine thickets, river, and beaches. The town, county, and surrounding areas were swamped with people. Then, after much growth, development, and sudden questionable "prosperity," World War II ended. This brought great relief and joy to the people of the town and to Navy and Marine personnel. It would also be a time for another great change in the community's structure. In Onslow County, Camp Davis closed down and the residents of Jacksonville were apprehensive that Camp Lejeune would be next. Some of the merchants had made a tremendous amount of money during the war. Some soon went bankrupt, but others persevered. It was a time of great uncertainty. But sometimes a difficult situation makes a community stronger, and Jacksonville and Camp Lejeune cooperated with each other, survived, and grew.

Jacksonville and Camp Lejeune would weather all of these changes and together face the challenges of the Korean War, the Vietnam War, Saudi Arabia, and many "peace keeping missions." They would work together to become a strong community where "The World's Most Complete Amphibious Training Base" would be located. It now serves 47,000 Marines and sailors. From the government's purchase of 11,000 acres of confiscated land, farms, farmhouses, tobacco barns, and the building of temporary tent cities and barracks, there had developed a premier military training facility covering 246 square miles. It is said that the base generates $2 billion in commerce each year. This comes through payrolls and contracts to support the training and equipment for our modern marines, their families, and support personnel. In this way, Camp Lejeune is one of the most important elements of this area's economy.

Jacksonville is now the large civilian commercial center of Onslow County. The area is home to active-duty Marines and their dependents, civil service employees, civilian employees, and military and civilian retirees. It has also become home to tourists who once came to visit and have returned to make their homes here in the warm climate near the beaches. From the 1950s to the 21st century, Jacksonville has seen its population grow from 3,960 to 70,365, and the population of Onslow County from 42,157 to 150,355. Here, citizens from every state in the union, and from countries all over the world, are united in one community. Together, we share a common goal—the greatest good for all.

Jacksonville continued to progress in spite of the economic slump following WW II. This picture shows a building being moved from Court Street to Tallman Street in the late 1940s to provide space for more modern buildings. (Photo by Dr. Stratton C. Murrell.)

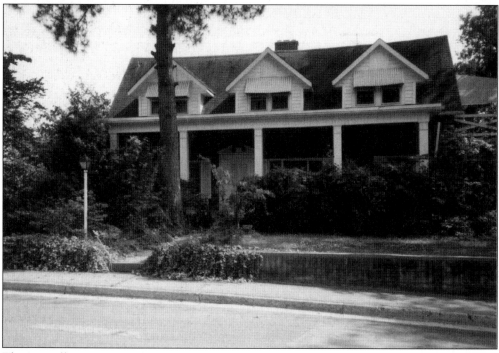

The Murrell House on Tallman Street is pictured in 1985 after it was moved and renovated. (Photo by Dr. Stratton C. Murrell.)

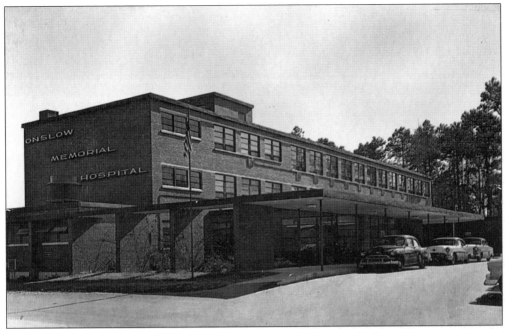

In the 1950s, a new 150-bed hospital was built on College Street near the first hospital, which had been built in 1943. The building of this facility brought more physicians and surgeons to the area. (Courtesy of Olese and Eloise Walton.)

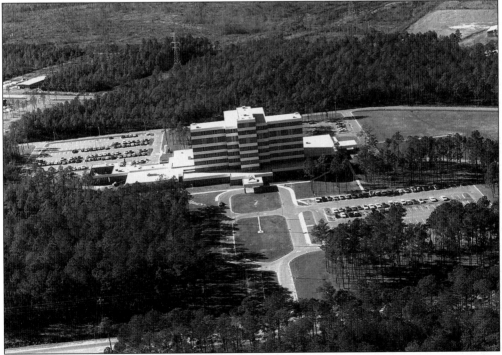

The latest hospital on Western Boulevard was built in 1974. The hospital is now surrounded by the offices of various medical specialists. Residents of Onslow County no longer feel that they must go elsewhere for good medical care. (Photo by Joe Bynum.)

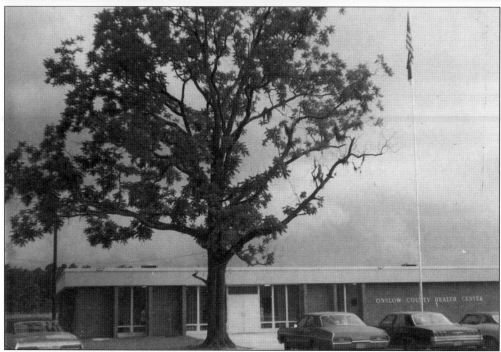

This is the third location of the Onslow County Public Health Department in the Georgetown section of Jacksonville in 1970. It offered many services to the public, including the control of communicable diseases, child care, family planning, home health, and school health services. (Courtesy of Naomi Cardwell.)

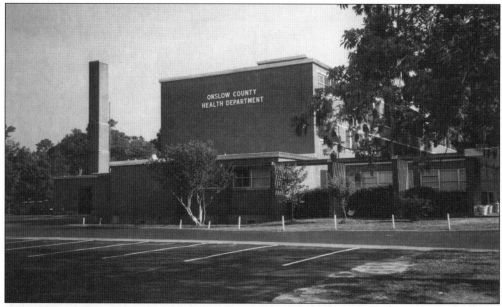

The present location of the Onslow County Public Health Department is in what was the second hospital building on College Street. Public Health services have increased to the point that this building now houses only Public Health Service Providers and their support staff. (Photo by Dr. Stratton C. Murrell.)

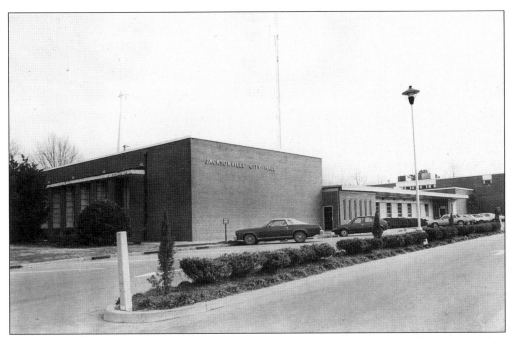

This 1956 photograph depicts Jacksonville's first city hall building, which is located on Highway 17. City hall has since been relocated and this original building is used as the police station and fire department. (Photo by Joe Bynum.)

The present city hall is in the old Belk Department Store building located on the corner of New Bridge Street and Bayshore Boulevard. At one time the U.S. Post Office was located on this corner. (Photo by Dr. Stratton C. Murrell.)

The post office was located on New Bridge Street in 1951. Prior to 1951, it was located on Court Street at the intersection of College Street. The Jacksonville Department Store was located on that site at a later date. (Courtesy of the Onslow County Museum.)

In 1965 a larger post office was built on the adjacent corner of New Bridge Street and Bayshore Boulevard. More businesses and residents led to the enlargement of this facility. In addition, branches were located in the New River Shopping Center area and in the Northwoods Shopping Center area. (Photo by Dr. Stratton C. Murrell.)

Downtown Jacksonville (Court Street) retained some small retail stores, including tattoo shops, jewelry stores, a shoe repair shop, pawn shops, and restaurants, as well as professional offices. Belk's Department Store was built on New Bridge Street, and many businesses on Court Street moved to New Bridge Street and to the New River Shopping Center, which opened in 1951. (Photo by Dr. Stratton C. Murrell.)

The decline of business activity on Court Street continued due to a lack of parking space. For the most part, the businesses were taken over by bars and adult entertainment establishments. (Photo by Dr. Stratton C. Murrell.)

In the 1930s, Johnson Drug was located on Old Bridge Street across from the courthouse. In 1961 their second store was opened on New Bridge Street, as many stores moved from the downtown area. The downtown store closed in 1971. A new store opened at West Park Shopping Center in 1978. (Photo by Dr. Stratton C. Murrell.)

The city purchased Court Street buildings. The white building shown at the corner of Tallman and Court Streets was the "famous" Jazz Land, a bar and dance club. This and the adjoining buildings were demolished, providing the space needed for parking near the courthouse and the old downtown area, but by then most of the retail stores had moved away from that area. (Photo by Dr. Stratton C. Murrell.)

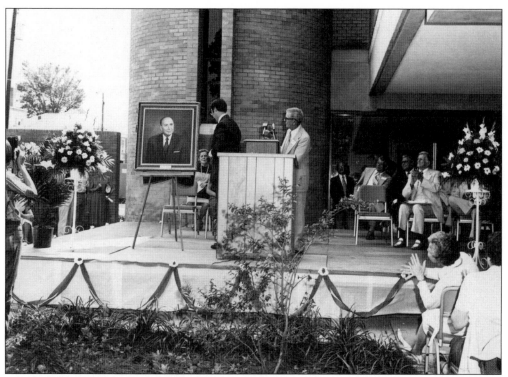

The dedication of the Summersill Building took place in 1978. (Photo by Joe Bynum.)

The Summersill Building was constructed in 1978 to provide additional space for courthouse services. It was named in honor of E.W. Summersill, a prominent attorney who was born and grew up in Onslow County. This building served many needs such as space for district court, housing for records, and meeting space for the county commissioners and other groups concerned with county government. (Courtesy of the *Daily News*.)

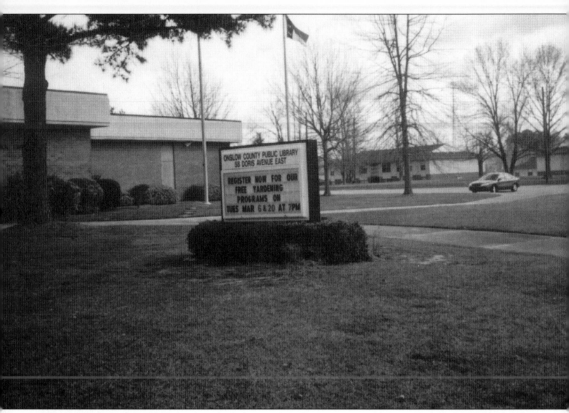

The Onslow County Library, currently located at 58 Doris Avenue East, has had various homes throughout the history of Jacksonville. It began as a branch of the library established by the Women's Club in Richlands but became the main library in the 1940s. It has been located at Pine Lodge, the courthouse, and in a small building on Mill Avenue next to the ABC store. It was moved to a new building on Henderson Drive in 1968. The Onslow County Library was last moved and dedicated at its present location on July 18, 1976. This facility is a very important part of the educational fiber of the city and the county. It is equipped with a knowledgeable staff who willingly aid patrons as they use the thousands of books, videos, computers, and available research facilities. At the present time there is a need for a larger facility. (Photo by Dr. Stratton C. Murrell.)

Coastal Carolina Community College (CCCC) is located on a large campus off Western Boulevard in the north section of Jacksonville. It was chartered as Onslow County Industrial Education Center in 1964 under the capable leadership of James Leroy Henderson. His foresight, extraordinary effort, and dedication to education were key to the growth and development of the center. By 1967 it had become Onslow County Technical Institute, and by 1970 it became CCCC. The first building on the permanent campus was built in 1972 and named in honor of Hugh A. Ragsdale, who had made many contributions in the areas of education, civic and public affairs, and government. Dr. Henderson and the members of CCCC's Board of Trustees invested much of their time and energy in the development of an institution that is one of the best community colleges in the state of North Carolina. It offers programs in vocational, technical, and college transfer areas of study. Dr. Henderson retired from his position as president of the college in 1987. Dr. Ronald Lingle became president in 1988 and remains in that position at the present time. (Photo by Dr. Stratton C. Murrell.)

The offices for the administration of the Onslow County School System are located in the Georgetown section of Jacksonville. This system is responsible for 17 elementary schools, 7 middle schools, and 6 high schools. Employees of the Onslow County School System are employed by the state of North Carolina, while Camp Lejeune school personnel are employed by the U.S. government. (Photo by Dr. Stratton C. Murrell.)

Jacksonville High School, located on Henderson Drive, is shown as an example of one of the large high schools in this area. The high school building of the 1940s has been renovated and is now the Jacksonville New Bridge Middle School. (Photo by Dr. Stratton C. Murrell.)

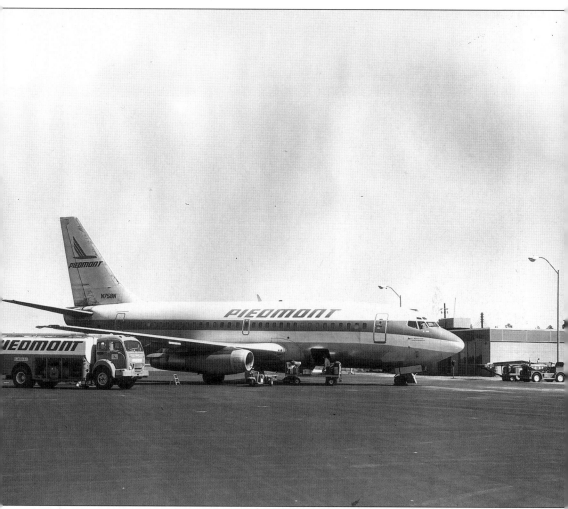

This is a picture of the first Piedmont jet plane to land at the Albert J. Ellis Airport, which was built in 1971. Albert J. Ellis was an attorney who was mainly responsible for an airport being built in Onslow County. Before this time the citizens of Jacksonville had to travel to Wilmington or Raleigh to board a plane. In the beginning there was a 5,200-foot runway, which was later expanded to a 7,100 feet. This made it possible for larger planes to use the facility. This airport was used by large numbers of the air-traveling public for 20 years. The larger airlines then decided that it was no longer profitable to use the small airport. At the present time residents must use a shuttle service to board a plane at a larger air terminal. Efforts continue by both city and county governments to attract the return of the larger airlines. (Photo by Joe Bynum.)

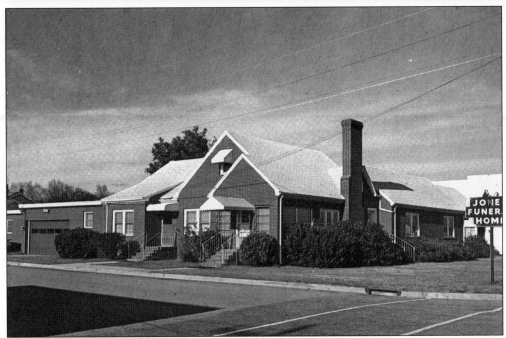

The Jones Funeral Home and Chapel is a family-owned business that was established by G.W. Jones on New Bridge Street in 1920. It has since been moved to Chaney Avenue and is one of two family-owned businesses that have survived into the 21st century. (Courtesy of Olese and Eloise Walton.)

The renovated Jones Funeral Home and Chapel on Chaney Avenue continues as a family-owned business. The current president is Jerry Jones, the grandson of the founder. (Photo by Dr. Stratton C. Murrell.)

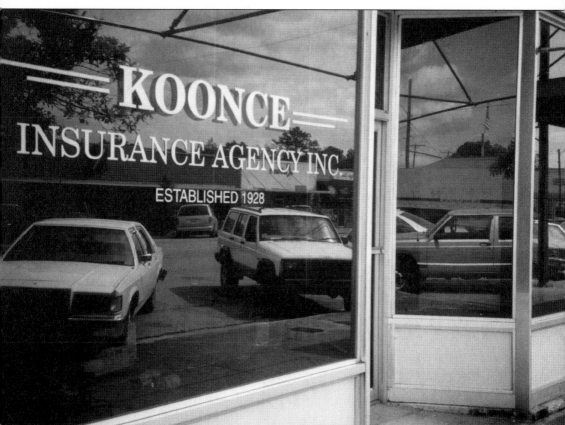

The Koonce Insurance Agency was established in 1928 by T.B. Koonce and located on Court Street. It was moved to New Bridge Street and is now located on the Gum Branch Road. The business is operated by Cal and David Koonce, grandsons of the founder. T.B. Koonce not only began the insurance agency, but he owned the farm in the Wilson Bay area that was the site of the first housing development in Jacksonville in the 1940s. This housing development was known as Pine Ridge and many of its original private homes are still occupied. The Koonce family has always been active in the business and civic affairs of Jacksonville and Camp Lejeune. (Photo by Dr. Stratton C. Murrell.)

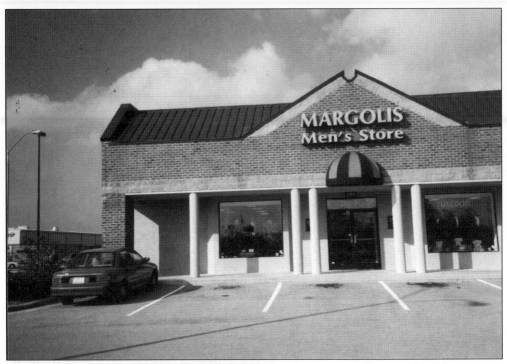

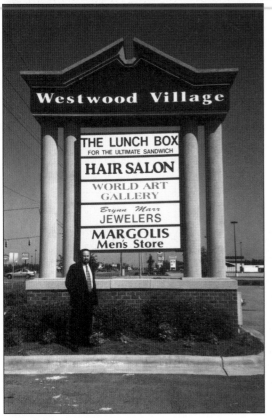

Margolis Men's Store is the oldest surviving retail business name in Jacksonville. It has dressed the large and the small, the great and the tall gentlemen of this area since 1912. This business was established on Court Street by Max Margolis. (Photo by Dr. Stratton C. Murrell.)

Margolis Men's Store was moved to the New River Shopping Center in 1976 and to its present location at Westwood Village on Western Boulevard Extension in 1994. It is now owned by Lloyd Koonce, pictured here. The store continues to offer quality clothing for the gentlemen of this area. (Photo by Dr. Stratton C. Murrell.)

The Jacksonville Mall on Western Boulevard was not built until 1981. Western Boulevard was paved in 1969 to accommodate traffic to the Bryn Marr Shopping Center, the Bryn Marr Housing Development, Onslow Memorial Hospital, Doctor's Park, and Coastal Carolina Community College. Many large retail stores moved into the mall. These included Belk's, Sears, J.C. Penney, and Reed's Jewelry. (Photo by Dr. Stratton C. Murrell.)

After the Jacksonville Mall was built, other retail businesses, restaurants, and professional offices were constructed along Western Boulevard. (Photo by Dr. Stratton C. Murrell.)

The United States Marine Corps and Jacksonville, North Carolina have come a long way since September 1941, when a Marine division set up camp in the middle of a sandy pine thicket and began the establishment of what is now Camp Lejeune. (Courtesy of the Graphics Department, Marine Corps Base, Camp Lejeune.)

Jacksonville is now the home of the Marine Corps Base, Camp Lejeune. Marines, sailors, family members, and military and civilian retirees have grown into a thriving, caring community. (Courtesy of the Graphics Department, Marine Corps Base, Camp Lejeune.)

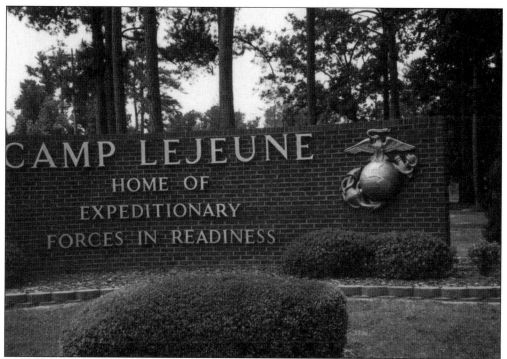

A 2001 view illustrates the entrance to the main gate of Camp Lejeune. (Photo by Dr. Stratton C. Murrell.)

The main gate to Camp Lejeune has also come a long way since 1942. The road is no longer a sandy trail but paved, landscaped, and guarded by a well-dressed young Marine. (Photo by Dr. Stratton C. Murrell.)

This map is prominently displayed in a visitor's area as one approaches the main gate. It highlights interesting points open to visitors as they drive through the base. (Photo by Dr. Stratton C. Murrell.)

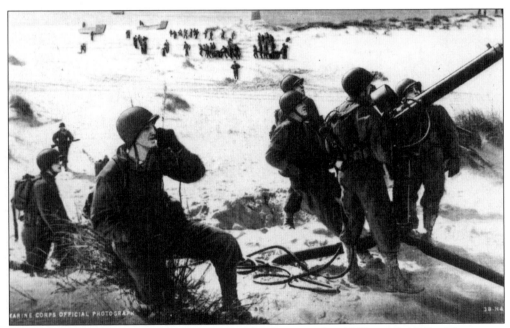

Anti-aircraft training at Camp Lejeune took place in the 1940s and 1950s. Now, very different weapons are used to bring down aircraft. (Courtesy of the Department of Archives and History, Raleigh.)

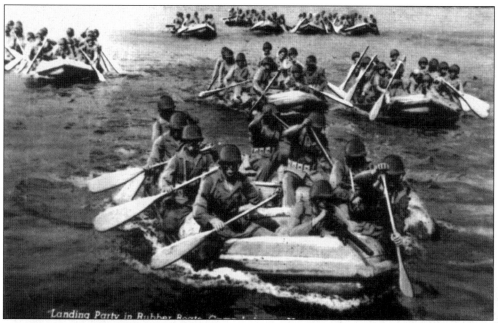

A landing party uses rubber boats at Camp Lejeune in the 1950s. No visitors were allowed here! (Courtesy of the Department of Archives and History, Raleigh.)

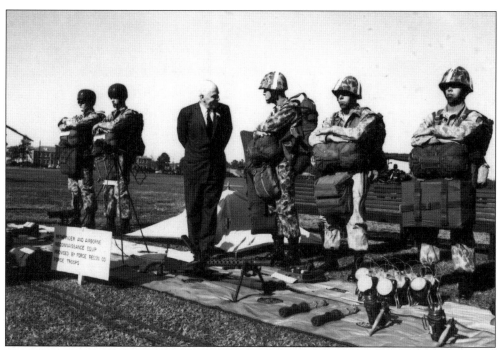

North Carolina's governor J. Melville Broughton visited the troops in 1958 and is pictured here being shown many of the weapons and equipment used by the Marines. Dignitaries often visit military installations as gestures of interest and good will. (Courtesy of the Department of Archives and History, Raleigh.)

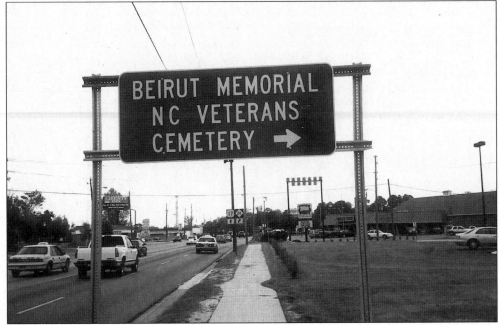

Driving from Jacksonville to the main gate of Camp Lejeune on Highway 24 one will see the sign to the Beirut Memorial and the North Carolina Veteran's Cemetery, which is at the entrance of Camp Johnson. (Photo by Dr. Stratton C. Murrell.)

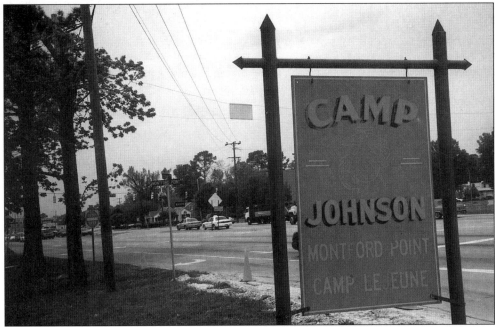

The entrance to Camp Johnson is shown at Montford Point, Camp Lejeune. In the 1940s Camp Johnson was the first basic training camp of the U.S. Marine Corps for African Americans. These troops were quartered at Montford Point, which is now known as Camp Johnson in honor of Sgt. Maj. Gilbert "Hashmark" Johnson, an outstanding African-American Marine officer. (Photo by Dr. Stratton C. Murrell.)

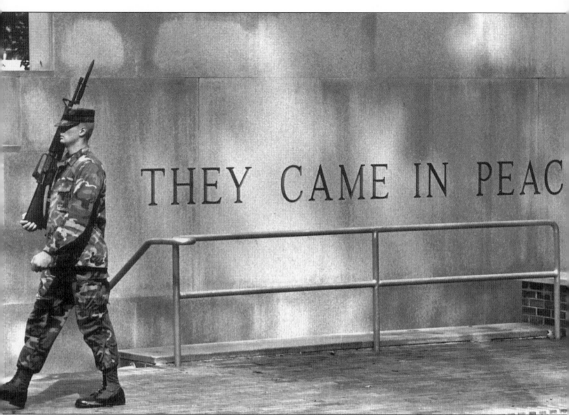

At the entrance to Camp Johnson stands the Beirut Memorial in honor of the 262 Marines and sailors who gave their lives while on a peace-keeping mission in Beirut, Lebanon, in October 1983. The bombing of the Battalion Landing Team's headquarters touched all of our lives. All of the men who died were stationed in North Carolina. (Photo by Randy Davey of the *Daily News.*)

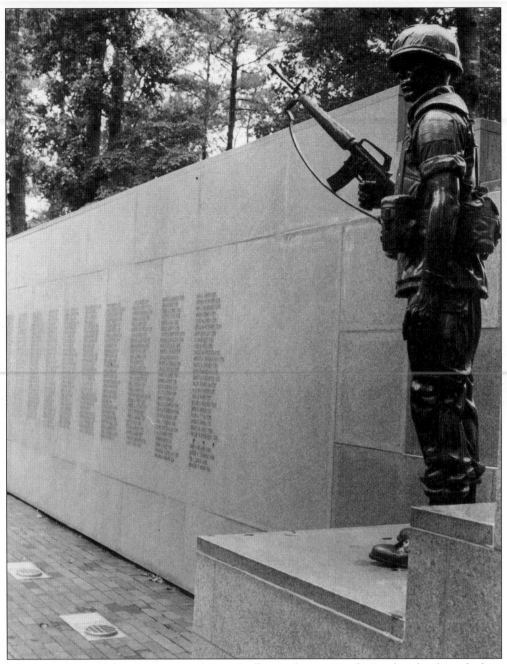

The Beirut Memorial is a quiet monument of tall trees, brown North Carolina brick, and white Carolina granite, with the names of the 262 military personnel etched into the wall. There is an adjacent wall telling why this memorial has been constructed. On a platform between the two walls stands a life-size bronze statue of a Marine keeping vigil over his fellow comrades. The memorial was designed by Todd W. Neal and Wendy C. Moses of the North Carolina School of Design of North Carolina State University. Woody Myers constructed the memorial and Abbe Godwin, a native of North Carolina, was the sculptor of the bronze statue. (Courtesy of the *Daily News*.)

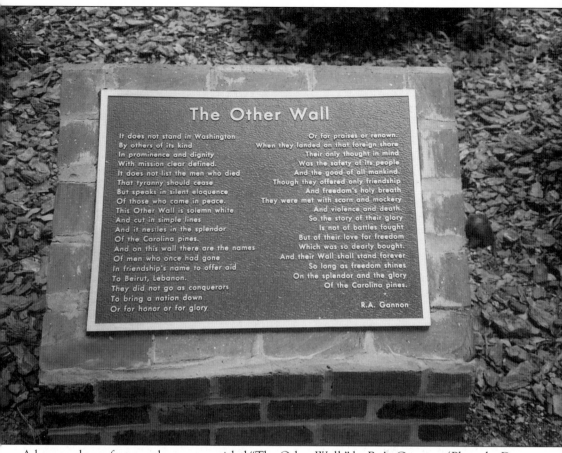

A bronze plaque features the poem entitled "The Other Wall," by R.A. Gannon. (Photo by Dr. Stratton C. Murrell.)

It does not stand in Washington
By others of its kind
In prominence and dignity
With mission clear defined.
It does not list the men who died
That tyranny should cease,
But speaks in silent eloquence
Of those who came in peace.
This other wall is solemn white
And cut in simple lines
And it nestles in the splendor
Of the Carolina pines.
And on this wall there are the names
Of men who once had gone
In friendship's name to offer aid
To Beirut, Lebanon.
They did not go as conquerors
To bring a nation down
Or for honor or for glory

Or for praises or renown.
When they landed on that foreign shore
Their only thought in mind
Was the safety of the people
And the good of all mankind.
Though they offered only friendship
And freedom's holy breath,
They were met with scorn and mockery
And violence and death.
So the story of their glory
Is not of battles fought,
But of their love for freedom
Which was so dearly bought.
And their wall shall stand forever
So long as freedom shines
On the splendor and the glory
Of the Carolina pines.

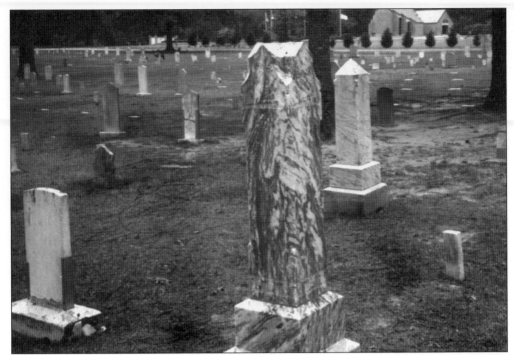

At the entrance to Camp Johnson there is a cemetery in which many North Carolina veterans are interred. Also found in this cemetery are the graves of people moved from private family cemeteries, which had been located on the property now occupied by Camp Lejeune. (Photo by Dr. Stratton C. Murrell.)

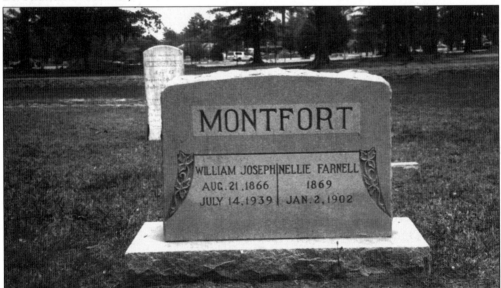

The Montfort gravestone was moved from property now occupied by Camp Lejeune at Montford Point. Some of the members of the Montfort family lived at Montford Point (different spelling, but same family). These bodies were moved from the property bought by the U.S. government and were re-buried at this cemetery at the entrance to Camp Johnson at Montford Point. (Photo by Dr. Stratton C. Murrell.)

The administration building at the traffic circle on Holcomb Boulevard is pictured as it was in 1980. It remains essentially the same today. (Courtesy of the *Daily News*.)

The celebration of the Marine Corps's 205th anniversary is observed in 1980. (Courtesy of the *Daily News*.)

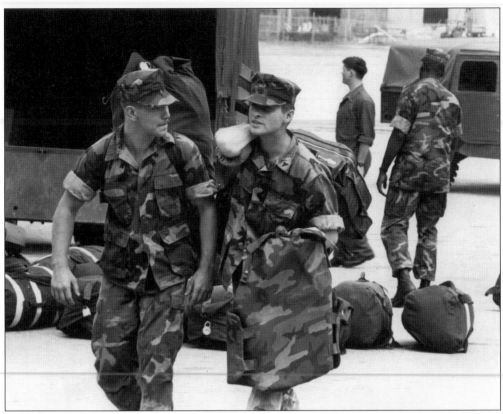

Marines prepare for embarkment. The men and women of the Marine Corps regularly pack up and go on special-training and peace-keeping exercises. "Semper fidelis," their motto, "always faithful" is demonstrated. (Photo by Randy Davey of the *Daily News*.)

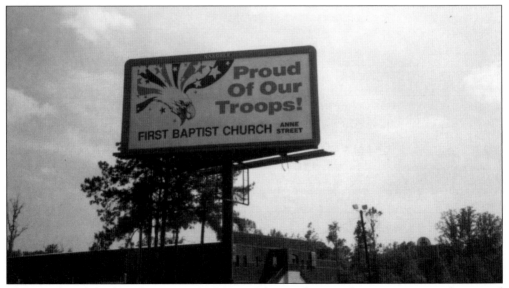

This sign board displays the community's grateful attitude toward troops serving at home and abroad in order to defend and preserve freedom. (Photo by Dr. Stratton C. Murrell.)

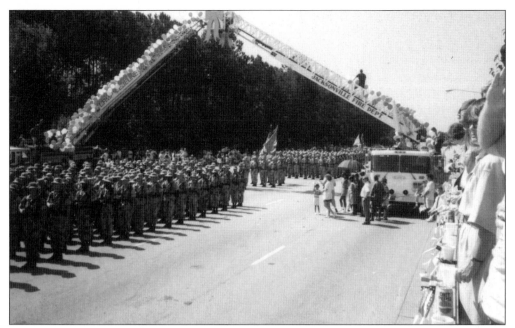

A community rejoices as the Marine and Navy personnel return home from the Desert Storm Conflict to their families and friends. They march under red, white, and blue balloons and yellow ribbons, symbols of a safe return home. (Photo by Dr. Stratton C. Murrell.)

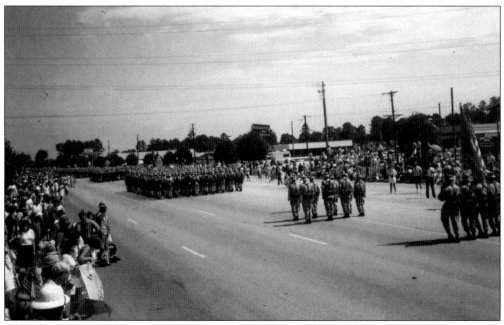

Western Boulevard is lined with people as the servicemen pass in review. (Photo by Dr. Stratton C. Murrell.)

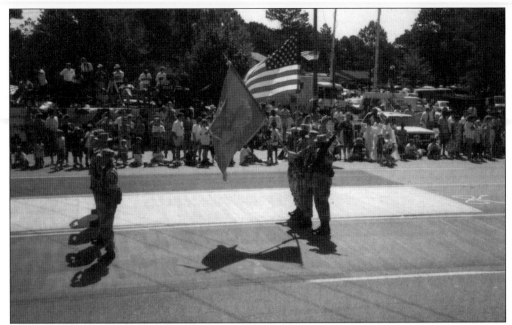

The red carpet was laid out for the return of the Marine and Navy troops from Desert Storm. (Photo by Dr. Stratton C. Murrell.)

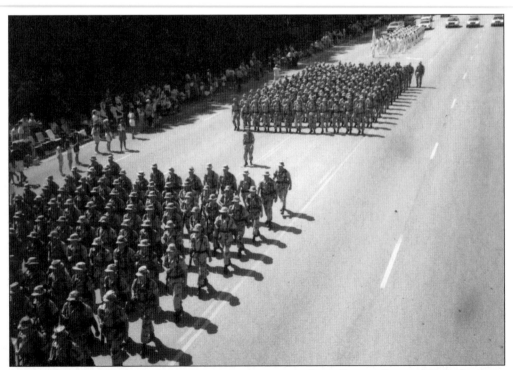

The community unites and rejoices as troops return from Desert Storm. Note the large contingent of Navy personnel at the end of the parade—their uniforms blend in with the pavement. (Photo by Dr. Stratton C. Murrell.)

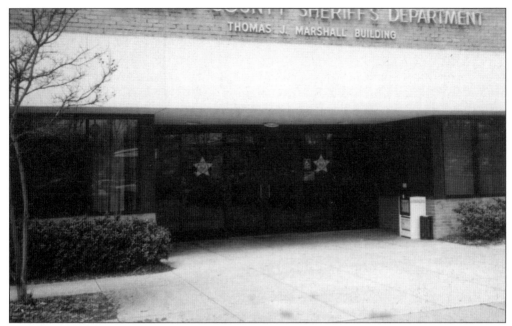

The Onslow County Sheriff's Department is located in the Thomas J. Marshall Building. Thomas J. Marshall was the sheriff of Onslow County from 1951 until 1978. (Photo by Dr. Stratton C. Murrell.)

Freedom's Fountain stands in front of the Thomas J. Marshall Building. The fountain was built in honor of the military personnel who have defended our freedom throughout the years. It was dedicated in 1997. (Photo by Dr. Stratton C. Murrell.)

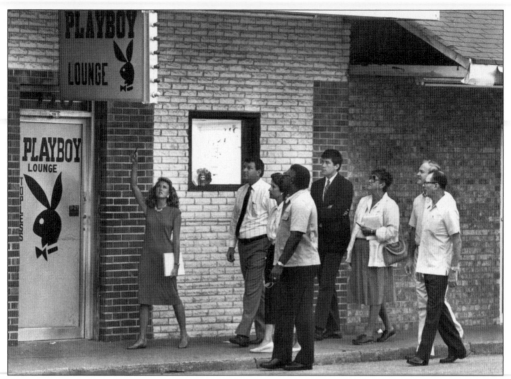

B.O.L.D.—Bettering Our Local Downtown—got its start in 1991. A committee surveyed the city streets and businesses to ascertain what needed to be done to improve appearances. This is one of the first groups that worked on this project. (Photo by Randy Davey of the *Daily News*.)

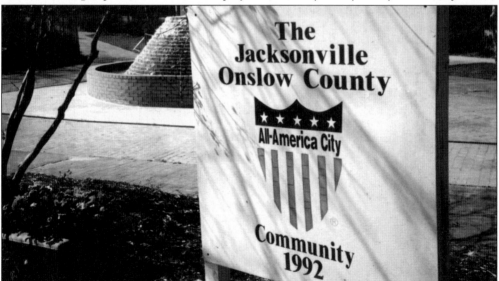

In 1992, Jacksonville, North Carolina was the recipient of the All-America City award. One of the All-America City logos stands in front of the Thomas J. Marshall building. This award recognizes the interaction and cooperation between citizens, government, businesses, and volunteer organizations in addressing and solving public issues and challenges. (Photo by Dr. Stratton C. Murrell.)

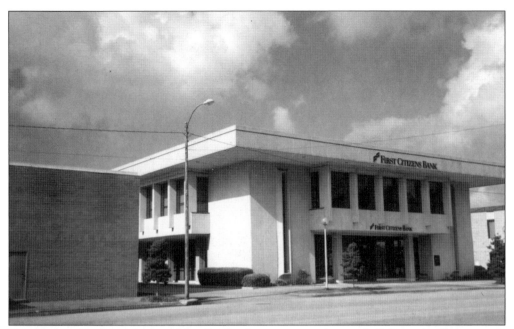

First Citizens Bank was built on New Bridge Street next to the city hall. Large banking centers and car dealerships were established on Highway 24 east towards the main gate of Camp Lejeune. Businesses continued to grow in that direction. (Photo by Dr. Stratton C. Murrell.)

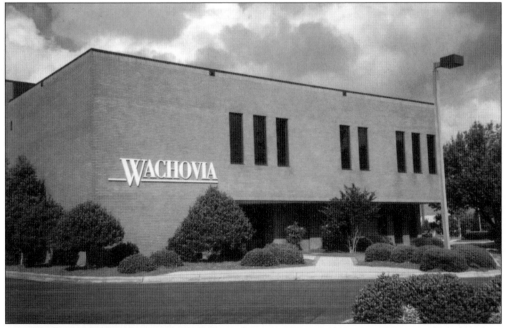

The Wachovia Banking Center was built at the intersection of Hargett Street and Highway 24 east towards the main gate. This was one of the first large banking centers in town. Banking and business continued to grow out from the original downtown area in all directions. (Photo by Dr. Stratton C. Murrell.)

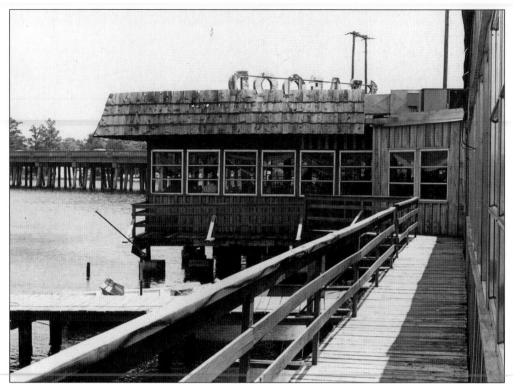

Fisherman's Wharf was built on the New River in 1972 with docking facilities. This structure is located on Highway 17 South next to the Herbert G. "Buddy" Phillips Bridge. (Photo by Joe Bynum.)

Several boats docked at Fisherman's Wharf, a steak and seafood restaurant built and owned by the Bynum brothers, who came to Jacksonville in the 1940s. (Photo by Joe Bynum.)

The Golden Corral Steak House moved from its original building to a larger building with more services in Western Plaza on Highway 17 North. (Photo by Dr. Stratton C. Murrell.)

Other businesses began to locate in Western Plaza at the intersection of Highway 17 North and the extension of Western Boulevard. Eventually a Wal-Mart Supercenter was built in this area. (Photo by Dr. Stratton C. Murrell.)

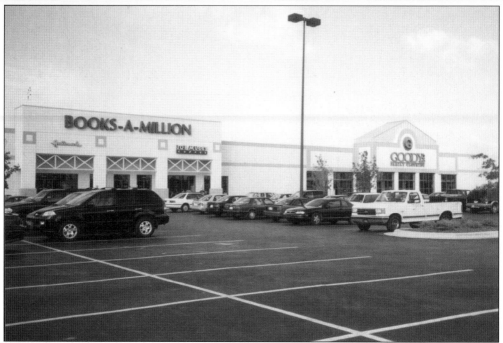

Business continues to expand down Western Boulevard Extension, bringing services that were not previously available to Jacksonville residents without traveling to another city. (Photo by Dr. Stratton C. Murrell.)

The motel industry sprang up along Highway 17 North beyond Western Boulevard. Until the 1990s there were few quality motels in Jacksonville to house the visitors, tourists, and business people who came to the area. (Photo by Dr. Stratton C. Murrell.)

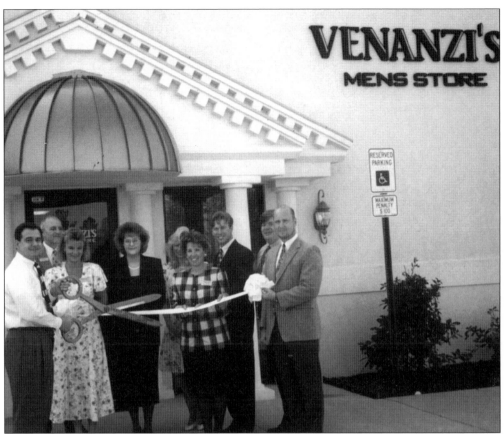

Venanzi's Men's Store was built on Henderson Drive Extension in the 1990s. (Courtesy of the Jacksonville-Onslow Chamber of Commerce.)

In the 1990s medical services in Jacksonville grew rapidly. This picture shows the development of the radiology center and other professional centers that were constructed along Henderson Drive Extension. (Photo by Dr. Stratton C. Murrell).

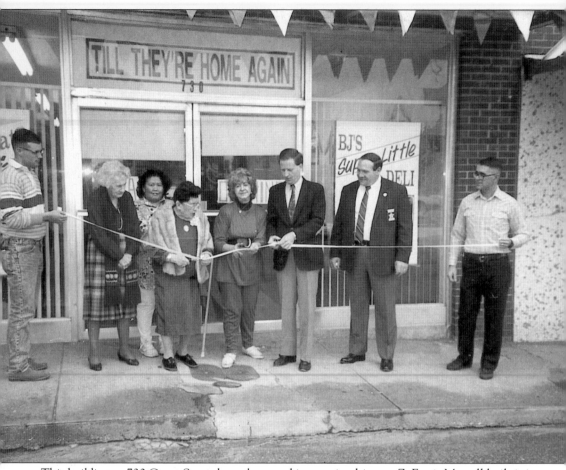

This building at 730 Court Street has a long and interesting history. Z. Ennis Murrell built it in 1950 to replace the building that he had constructed on this location in 1934. His business, Coastal Motor Company, operated out of this building until he relocated it to Lejeune Boulevard in the 1950s. The Court Street building was then rented and operated as a restaurant and sandwich shop. When this picture was made in 1990, the restaurant had just been re-opened and was operated by Bea Kullman. Pictured at the ribbon cutting on December 20, 1990 are, from left to right, unidentified, Thelma Langley, Jennie Kullman, Louise Murrell, Bea Kullman, Mayor George Jones, Sheriff Ed Brown, and Frank Kullman. This was one of the last attempts by the family to retain this building and keep it open as a viable business. This particular business failed because of the adverse effect of the Gulf War on the economy of Jacksonville. The decline on Court Street took its toll and the family sold the building in the year 2000. (Photo by Dr. Stratton C. Murrell.)

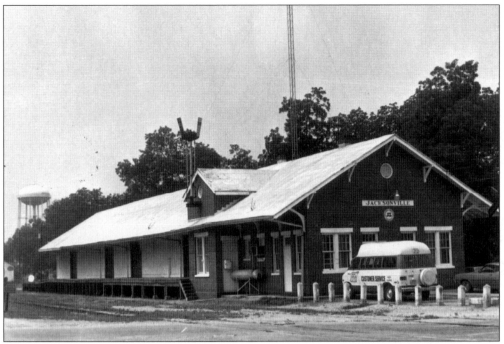

The Jacksonville Atlantic Coastline Depot building was abandoned in 1984 after rail service to Jacksonville was discontinued. Thanks to B.O.L.D. (Bettering Our Local Downtown) and to many of Jacksonville's residents and businesses, the structure has been preserved and renovated. (Courtesy of the Department of Archives and History, Raleigh.)

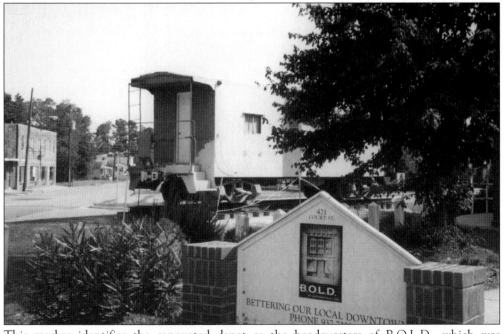

This marker identifies the renovated depot as the headquarters of B.O.L.D., which was organized in 1991. This organization is responsible for spearheading the master plan for the redevelopment of downtown Jacksonville. (Photo by Dr. Stratton C. Murrell.)

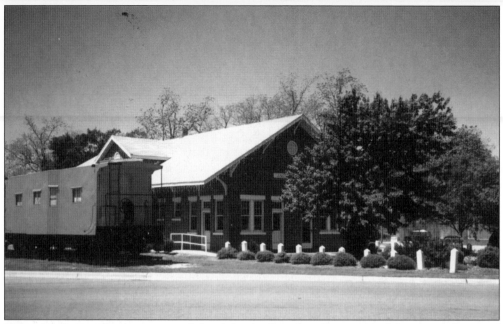

This view depicts the restoration of the Atlantic Coastline Depot. A celebration in honor of the restoration was held on April 15, 1998. At the time, Rosie Kandlin was the director of B.O.L.D. This building has been designated a historic landmark by the National Register of Historic Places. (Photo by Dr. Stratton C. Murrell.)

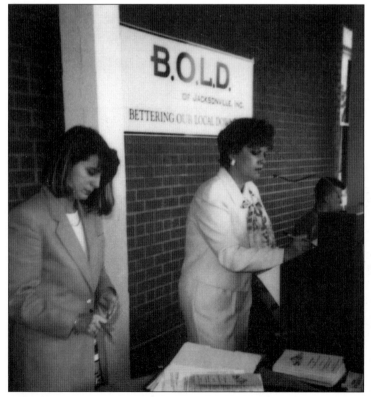

Pictured at the ceremony honoring the restoration of the Jacksonville Train Depot are Ann Shaw (left) and Rosie Kandlin at the podium. (Photo by Dr. Stratton C. Murrell.)

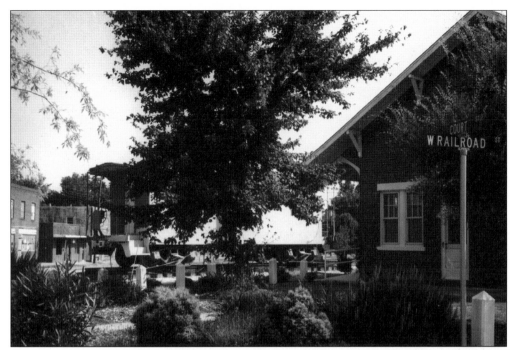

The corner of Court and West Railroad Streets is pictured as it looks today. The restoration of the downtown area is greatly encouraged by the activities of B.O.L.D. and the interest of citizens. Many newcomers to the area who are interested in historical restoration have also joined in this effort. (Photo by Dr. Stratton C. Murrell.)

The Dr. George Bender Home at 215 Mill Avenue has been restored and is now a bed-and-breakfast known as the Colonel's Lady. (Photo by Dr. Stratton C. Murrell.)

The W.L. Ketchum Home on New Bridge Street undergoes restoration. Built in 1931, this, the first brick home built in Jacksonville, is now a part of an office complex on New Bridge Street. (Photo by Dr. Stratton C. Murrell.)

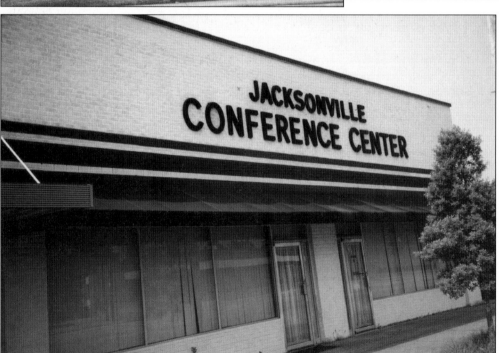

The Jacksonville Conference Center is at the intersection of New Bridge Street and Bayshore Boulevard. It was once the original Piggly Wiggly Supermarket in Jacksonville. (Photo by Dr. Stratton C. Murrell.)

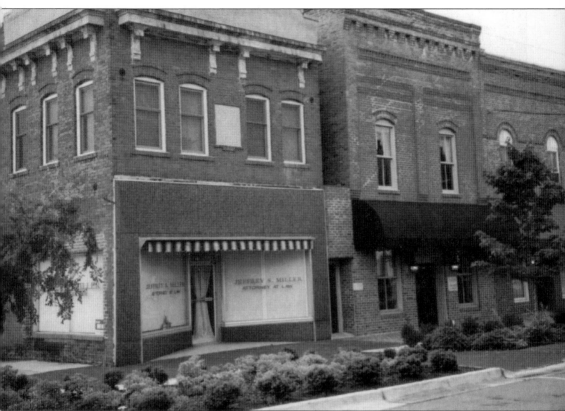

The Margolis Building (left), being renovated on Court Street, is now occupied by attorney Jeff Miller. Next to it are Collins and Moore attorneys offices and the district attorney's office. The restoration of this part of Court Street is graced by the addition of a landscaped brick plaza. As one proceeds down the street towards College Street one will find a charming sandwich shop called the Courthouse Café. Further down the street in a well-kept building is the Onslow County Community Ministries Administrative Offices, which includes the Homeless Shelter and Soup Kitchen. The Soup Kitchen is open every weekday and feeds not only the homeless, but many of the working poor. This is the Segerman Building, which was the Jacksonville Department Store. Across the street are the County Purchasing and Contracting Offices. (Photo by Dr. Stratton C. Murrell.)

Restoration continues in the historic area of the old downtown, and this view highlights the restored Richard Ward House at 202 Mill Avenue and originally built in the 1890s. Dr. Ward was very interested in development of real estate. He also had interests in the lumber business. (Photo by Dr. Stratton C. Murrell.)

Narcey Marine built this house in 1911, a short time after her husband died. Located at 300 Mill Avenue, it was later renovated and now operates as The Mill Avenue Bed-and-Breakfast. (Photo by Dr. Stratton C. Murrell.)

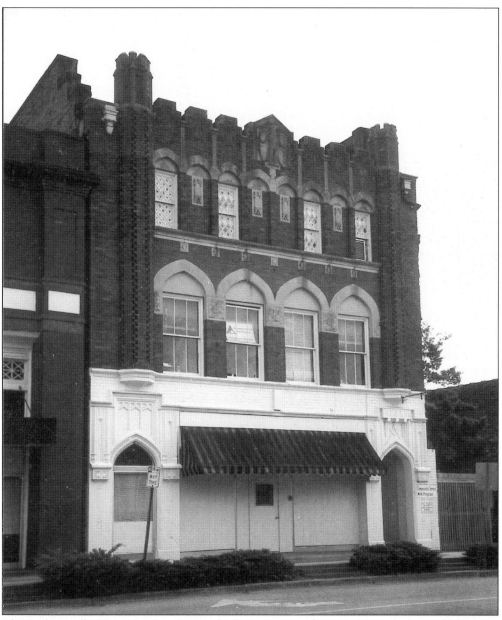

The Jacksonville Masonic Temple was built in 1919 and continues to be one of the most interesting structures in town. Located at 216 Old Bridge Street, it stands in great contrast to the other buildings on this street. The façade changes greatly as one looks up toward the top of the building. On the street level there are lancet-arched openings through which many have passed to transact business. Once home to Johnson Drug, the building later became a bar named The Oriental Star. The second level of this building has a row of lancet-arched windows, and on this level was the office of city attorney John D. Warlick in the late 1930s. There was no city hall at that time and the city council usually met in Warlick's office. The third level resembles the top of a medieval castle. In 1934 this building was sold to Graham Johnson, a pharmacist, who owned and operated Johnson Drug Store in this location until 1971, when the downtown store was closed. (Photo by Dr. Stratton C. Murrell.)

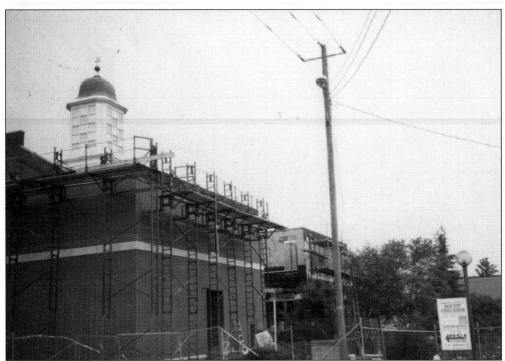

Planning for the extensive renovation and restoration of the Onslow County Courthouse began in 1997; here we see the renovation in progress. The architect for the renovation/restoration was Lee D. Dixon of Ellinwood Design Associates, Ltd. The courthouse had not had any major renovation or repair since the restoration in 1949. The architect for that earlier project was John J. Roland of Kinston, North Carolina. (Photo by Dr. Stratton C. Murrell.)

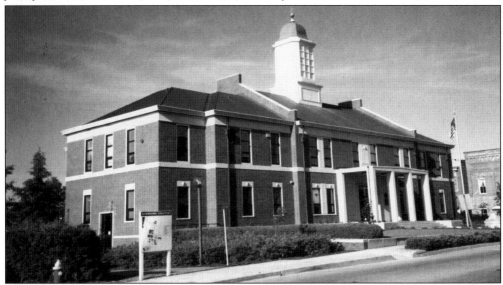

This photograph reveals the completed restoration and renovation of the courthouse. The grand re-opening of the 96-year-old structure was held on April 29, 2001. The traditional appearance of the courthouse exterior has been preserved, and the interior of the building has been improved and enhanced. (Photo by Dr. Stratton C. Murrell.)

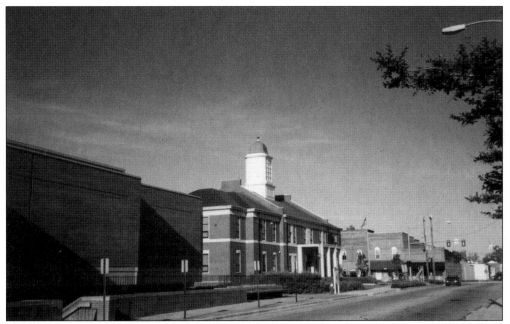

The existing court facilities cover an entire block of the city. The Summersill Building is in the foreground on the left and the newly renovated courthouse is beside it. Directly behind these buildings are the sheriff's office, the county jail, and a large parking area. (Photo by Dr. Stratton C. Murrell.)

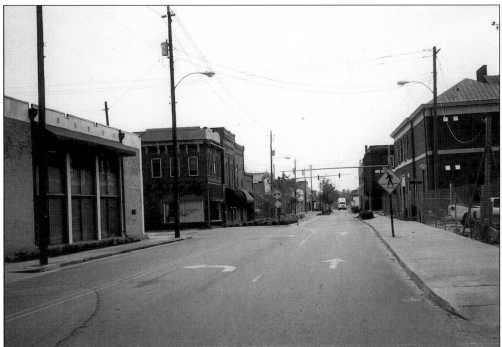

Court Street begins to show the effects of efforts to restore and rejuvenate its charm. This is an area of our city where living, working, shopping, dining, boating, and celebrating holidays may be enjoyed in safety. (Photo by Dr. Stratton C. Murrell.)

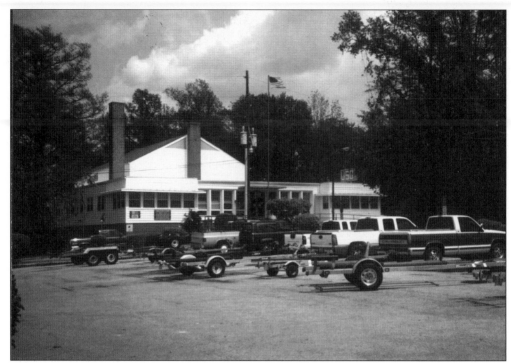

The USO building is located at the end of Tallman Street down by the river. Across the street is a lot where trailers are parked after people launch boats at the Waterfront Park landing; it was the site of Pine Lodge many years ago. This is again a recreational area serving both military personnel and civilians. (Photo by Dr. Stratton C. Murrell.)

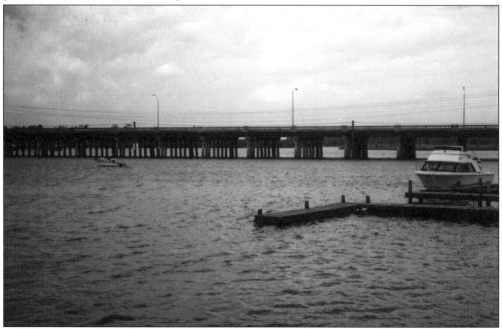

A boat has been launched into the New River at Waterfront Park; the Herbert G. "Buddy" Phillips bridge is in the background. (Photo by Dr. Stratton C. Murrell.)

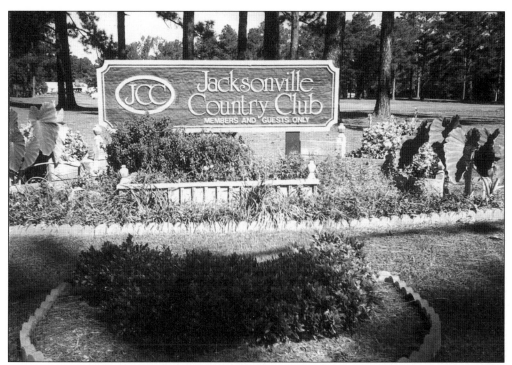

The Jacksonville Country Club, located on Country Club Road, was built in the 1950s. In 2001 the old building was torn down and construction began on its replacement. Many people continue to play golf on this beautiful course. (Photo by Dr. Stratton C. Murrell.)

Pictured here, from left to right, are JoAnn Becker, Marie Hinton Koonce Moore, and Bill Loy at the Onslow County Museum. Even though the Onslow County Museum is not located in Jacksonville, many Jacksonville residents participate in the activities it sponsors. (Photo by Dr. Stratton C. Murrell.)

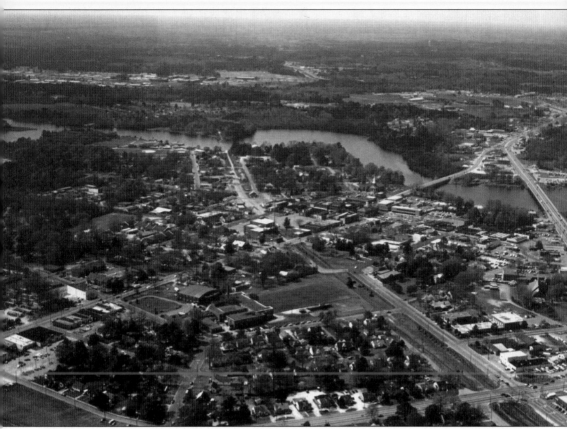

An aerial view shows Jacksonville in 1990, before much of the interest was sparked for the improvement of land along the New River. From the sparse development in the background of this picture, forward toward the river and the more heavily developed area, one can locate the Onslow County Courthouse and chart the progress of this area. Greater development is now occurring along the waterfront area as the residents and entrepreneurs see the need for environmental, recreational, and residential preservation and expansion. (Courtesy of Harry Lock.)

This picture shows the waterfront park that has developed along the New River between the old and new bridges as one enters the downtown area. Wantland's Spring is now surrounded by the square structure seen on the grounds of the Pelletier House. (Courtesy of the Jacksonville-Onslow Chamber of Commerce.)

The beauty of the waterfront park can be enjoyed while crossing the Jerry J. Popkin Bridge on Old Bridge Street. As one enters Jacksonville, going north toward New Bern, the Pelletier House, the Summersill Building, and the courthouse can be seen on the left while exiting the bridge. (Courtesy of the Jacksonville-Onslow Chamber of Commerce.)

Mr. Kenneth B. Hurst was born in 1909 in Onslow County, the son of William Hogan Hurst and Sallie Lorena Hurst Arthur. The Hurst family owned much of the land that made up Lejeune's original grounds. "Mr. K.B.'s" family owned about 1,364 acres and other Hurst family members owned about 2,200 acres at Onslow Beach. The land had been in the Hurst family since 1842 and was condemned and sold to the U.S. government for $1,600 in 1941. Mr. Hurst has made many contributions to the growth and development of Jacksonville and Onslow County. In the May 2, 1991 issue of the *Camp Lejeune Globe*, Hurst is quoted as saying that his family would be happy with how the land has been utilized and developed for the training young men and women in skills and disciplines which preserve the world's freedom. (Courtesy of Sara Hurst Thomas.)

Pictured here are Marie Hinton Koonce Moore (left) and Thelma Batts Langley (right). These ladies are two of Jacksonville's living voices of history. Miss Marie is 87 years old, was born in Jacksonville, and has lived here all of her life. Her father and his business partner, John Koonce, built the first brick business building on Court Street. Her father also built the first house on New Bridge Street. Miss Thelma is 97 years old and was born in Jones County. She married Arthur William Langley in 1924. Langley opened a grocery store on Court Street in the mid-1920s. Most of his business life was spent in the mercantile business. Miss Thelma is responsible for the rescue and restoration of the Averitt House, built in 1855 at Catherine Lake. Both of these ladies are now and always have been very active in the community and church. They remain gracious, helpful, and caring individuals, and are both community treasures. (Photo by Dr. Stratton C. Murrell.)

A U.S. Marine Corps Drill Team demonstrates precision, perfection, and cooperation. They are always greatly admired by observers. These drill teams demonstrate military precision and discipline at parades and other special occasions. (Photo by Randy Davey of the *Daily News*.)

The Honor Guard, leading a parade, is an impressive representative of Camp Lejeune and its satellite facilities. The community of Jacksonville and the surrounding areas are proud of their friends and neighbors at the base. Many have come here from all over the United States as well as foreign countries. They have added much to the community and the lives of its residents. Many of them return to this duty station several times during their military careers and some remain in the community after retirement. Because of their presence here, we are truly an international community. (Courtesy of the Jacksonville-Onslow Chamber of Commerce.)

Lt. Gen. John A. Lejeune, 13th commandant of the U.S. Marine Corps, would undoubtedly be pleased with his namesake, Camp Lejeune, "Home of Expeditionary Forces in Readiness." The spirit of General Lejeune can be seen in the upper right-hand corner of this picture, overlooking the activities of the base. (Courtesy of the Graphics Department, Marine Corps Base, Camp Lejeune.)